ICONS

20th Century Photography

Museum Ludwig Cologne

1,00

Cover: Herbert Bayer,
Lonesome Big City Dweller, 1932
© VG Bild-Kunst, Bonn 2001

Concept: Reinhold Mißelbeck
Authors of texts about photographers:
Marianne Bieger-Thielemann (*MBT*), Gérard A. Goodrow
(*GG*), Lilian Haberer (*LH*), Reinhold Mißelbeck (*RM*),
Ute Pröllochs (*UP*), Anke Solbrig (*AS*),
Thomas von Taschitzki (*TvT*), Nina Zschocke (*NZ*)
Reproduction of the images:
Rheinisches Bildarchiv, Cologne
Closing date: February 2001

© 2001 TASCHEN GmbH
Hohenzollernring 53, D-50672 Köln
www.taschen.com
© on the images rest with VG Bild-Kunst, Bonn,
the photographers, their agencies and estates

Editing and layout: Simone Philippi, Cologne
Cover design: Angelika Taschen, Claudia Frey, Cologne
English translation: Rolf Fricke, Phyllis Riefler-Bonham
Editorial co-ordination: Karl Georg Cadenbach

Printed in Italy
ISBN 3-8228-5514-6

20th Century
Photography
Museum Ludwig
Cologne

TASCHEN

KÖLN LONDON MADRID NEW YORK TOKYO PARIS

Highlights

Reinhold Mißelbeck

The selection of works from the Photographic Collection at the Museum Ludwig, Cologne, that I put together in 1996 for Taschen has in the last few years developed into a handbook of 20th-century photography. With its mixture of world-famous names and young, aspiring artists, the book provides a broad overview of both the development of photography and its most important representatives. Leafing through the book, the reader will encounter an astonishing number of works that are regarded as icons of 20th-century photography.

This has prompted the museum and the publishing house to produce a selection that concentrates on precisely these pictures, and thus to underline once just what treasures the Collection has amassed over the last twenty years, most particularly with the purchase of the Gruber Collection, the Mantz Collection, and Chargesheimer's estate. It embraces European and American photography from 1900 to the present, with special sections devoted to Cecil Beaton, Robert Capa, Henri Cartier-Bresson, Chargesheimer, William Klein, Irving Penn, Man Ray, Albert Renger-Patzsch, Karl Hugo Schmölz, Harold Edgerton, Gertrude Fehr, August Sander, Erich Salomon, Edward Steichen and Alfred Stieglitz. A number of the most prominent Japanese photographers are likewise represented in the form of Kishin Shinoyama and Hiroshi Hamaya. The Ludwig Collection has also been able to add a number of Russian photographers, such as Alexander Rodchenko, Georgii Petrussow, and Boris Ignatovich, and artist's photography has also been included in the collection, as represented by Jürgen Klauke, Anna and Bernhard Johannes Blume, Astrid Klein, Andreas Gurski, Caroline Dlugos, Floris M. Neusüss, Gottfried Helnwein, Bernd and Hilla Becher, Rudolf Bonvie, Les Krims, Robert Mapplethorpe, Philip-Lorca diCorcia, Thomas Locher and Cindy Sherman. Larger important additions to the collection over the last two decades include an archive belonging to Albert Renger-Patzsch containing 1000 negatives, the second section of Chargesheimer's estate, the estate of Heinz Held, the Eva Siao Archive, Roberto Otero's Picasso portraits, portraits of artists by Benjamin Katz, the Uwe Scheid Collection of contemporary photography, works by young Czech photographers, photographs from the German

Democratic Republic, and numerous bequests from Renate and L. Fritz Gruber amounting to some 2000 photographs. The present book of selected examples aims at providing a quick journey through 20th-century photography taking one particular collection as its basis.

In many ways, the beginning of the 20th century was a turning point marked by new departures and radical breaks with the past. In the USA, the Armory Show of 1913 and the activities of the Gallery 291 run by Alfred Stieglitz and Edward Steichen managed all at once to open the American art world to the European avant-garde scene. In 1907 Alfred Stieglitz had rung in a new era with his photograph *The Steerage* (ill. p. 181). Stieglitz was fully aware as he took the picture that the ensuing work would have major repercussions on the future development of photography. Looking back on this picture, he later wrote that it introduced a new era of seeing because it was concerned with relations between forms, and simultaneously with a deep human feeling, which spelt an important step in his development. To this he added that he would be happy if every one of his photographs were to be lost so long as *The Steerage* at least were to survive.

In Germany, Modernism was presented by the Sonderbund Exhibition of 1912 in Cologne, after Expressionism in Berlin and the Blaue Reiter group in Munich had already heralded the independence of the picture per se and the departure from representation. In Paris, the path towards abstraction was paved by Picasso and Braque with Cubism, and by Mondrian with his Neoplasticism. The British Vorticists took a similar route and inspired Alvin Langdon Coburn to his photographic experiments, the "Vortographs". In Italy the Futurists extended the realm that could be perceived by art by painting movements and sounds, and later the Dadaists and Surrealists across Europe rang in the age of intermedia with their actions, recitations, montages and installations. Surrealism and the Bauhaus brought great changes to photography, for their leading representatives introduced new techniques and subjects to the field.

In Russia the Revolution had led to radical changes in culture as a whole. During the years of the non-Socialist Duma government, Cubo-futurism and Rayonism had acted as a connecting link to the Internationale. Two important developments arose amid the whirl of revolutionary events: a mass culture in the form of Proletkult, and parallel to this but in dialogue with Western European currents, Suprematism,

which constituted an aesthetic programme that combined the applied disciplines of of architecture and design with the fine arts. Photography drew its inspiration first and foremost from the mass parades, as for instance in Petrussow's sea of soldiers' helmets (ill. p. 147), or in Alexander Rodchenko's *Dynamo Club* (ill. p. 152), and took Constructivism and the idea of movement and dynamism as its model.

The invention of photography, as people popularly say, liberated painting from the need to replicate reality. In doing so, it inherited such genres as the portrait and historical painting and contributed to the development of Modernism. The fact that this process first took place some seventy years after the invention of photography, after painting had worked its way through Naturalistic and Realistic tendencies and on through Impressionism, in no way contradicts this view. It demonstrates rather that a lengthy dialogue took place, and that it was precisely the experiences that painting gained through Naturalism and Impressionism that made it clear that photography was far better equipped for the exact representation of reality and for capturing moods and moments, and by a certain stage in the developments it was clear to everyone that the two media had quite different agendas.

Looking aside from a few such attempts as Alvin Langdon Coburn's "Vortographs", the "Schadographs" (ill. p. 160/161) or the "Rayographs", which continued the dialogue with kindred experiments in painting, the liberation of the fine arts proved a great stimulus to photography. It could devote itself to documentation and reporting, while also embracing a conceptual current, which, through Bernd and Hilla Becher (ill. p. 26/27) and their pupils, set in motion a process at the end of the last century that has led to the gradual erasure of this division at the beginning of the current century.

During the second and third decades of the last century, America saw the development of the social-documentary photograph as a major current in photography. An important protagonist of this genre was Lewis Hine. Already in 1905 he had begun – quite contrary to the prevailing tradition of Pictorial photographers – photographing the immigrants on Ellis Island, and later he worked for the National Child Labor Committee. It was during this assignment that he created his moving series on child labourers (ill. p. 85). In 1930 he began his series on "the men who built the Empire State Building", until he was commissioned in 1936 to document the effects of Roosevelt's New Deal. This commis-

sion led in turn to a series on the interaction between man and machine, albeit ultimately on the dominance of the latter. Lewis Hine's work is directly linked with that of Dorothea Lange and Walker Evans, among others, who were employed by the Farm Security Administration (FSA). Dorothea Lange's *Migrant Mother* (ill. p. 115) is the most-published photograph in the collection and a milestone in photographic history. The photographers were spurred on by their social commitment and the hope that their images might be able to initiate some kind of change. These photographers mark the beginning of a tradition that goes under the name "Concerned Photographers". Numerous photojournalists, such as Robert Capa, Werner Bischof, Margaret Bourke-White and Eugene Smith, to name a few, have kept the tradition alive through the century. Robert Capa's photograph of a Legalist struck by a bullet during the Spanish Civil War has become one of the most celebrated pictures of photographic history.

A third aspect of American photography dating from this time is typified by the work of photographers such as Weegee and Diane Arbus. Weegee prided himself on always being the first to arrive at the scene of a crime or disaster. He had an incomparable eye for the strange, the ugly, and indeed everything that departed from the norm. Weegee created contorted, grimacing portraits of famous celebrities (ill. p. 186) and amused himself over the stars of New York's night life (ill. p. 187). His dissecting gaze places him close to Diane Arbus and her study of ludicrous-looking nudists (ill. p. 17). The work of these two is reminiscent of Surrealist photography, yet without in any way being contrived or invented. They both discovered their absurd motifs in the heart of life – making this kind of surrealism especially photographic.

The great American landscape photograph is yet a further chapter of a history of photographic style built upon its own traditions. Ansel Adams (ill. p. 14/15) is without doubt the most famous representative of this direction, which not only established a form of art photography and thus a unique, indigenous history of photography, but also exerted a worldwide influence. In 1932 Adams formed together with Imogen Cunningham, Henry Swift, Sonya Noskowiak, John Paul Edwards and Edward Weston (ill. p. 189/189) a group of like-minded photographers under the name "f/64". Their aim was to forge a new photography that obeyed its own rules. Although these champions of "Straight Photography", as they termed it, were following in the footsteps of Alfred

Stieglitz, they nevertheless laid claim to the label "artist", and thereby established the tradition of artistic photography and its own specific history.

In Europe attention was directed at this time to somewhat different issues. There was no movement comparable to the "f/64" group, nor any interest in outsiders similar to that of Weegee or Arbus, nor any interest on the part of the state to use photography to document social conditions, as could be seen in the USA with the FSA or the National Child Labor Committee. The only exception was in the field of photogrammetry, which was used for the recording and preservation of monuments. This method exploited the documentary qualities of the photographic exposure, without however viewing the results in the context of art.

In France a photographic movement sprung up around Henri Cartier-Bresson that is often referred to as "author's photography". It pursues its own set aims and subjects, and comes up with its own principles and individual style. The photographers work by and large as freelances and publish their work in magazines and books. Their working methods are photo-journalistic, and their chief interest consisted in observing people in both everyday and exception circumstances, from the whole world. Henri Cartier-Bresson achieved real mastery in the genre, and proved that it is not a matter of the camera viewing something objectively, but of the photographer's eye subjectively perceiving a moment and capturing it. One of his most famous images is his *Sunday on the Banks of the Marne*, a photograph that gives a typical picture of the French petty bourgeois (ill. p. 40). Generations of photographers have taken this photograph as their model. Particularly noteworthy representatives of this genre are Brassaï (ill. p. 34/35), Chargesheimer (ill. p. 42/43), Alfred Eisenstaedt (ill. p. 54/55), Ed van der Elsken (ill. p. 55/56), André Kertész (ill. p. 104/105), William Klein (ill. p. 108/109) and Robert Lebeck (ill. p. 118/119). Jacques-Henri Lartigue could be regarded as the grandfather of this kind of photography, a man who, as the scion of a wealthy family, began in the first decade of the 20th century to record the leisure activities of the rich Parisians with a wry humour (ill. p. 116/117). In the very best examples of author's photography it becomes clear, however, that essentially this highly photographic genre is close in heart to the Dadaist principle of Marcel Duchamp: art should be found rather than created by hand. It

is telling in this connection that since the late 90s, the author's photograph has become assimilated and annexed by the fine arts – much as was the case with the Becher's pupils and the tradition of object photography. The stagings done by artists such as Philip-Lorca diCorcia (ill. p. 46/47) have opened the way for works that span the gap to fine art – ranging from those of Barclay Hughes and Beat Streuli, to the museum scenes of Thomas Struth. With that, yet another branch of photography can be integrated alongside author's photography into the history of art.

The German contribution to the history of photography during these years tends to have a sober, matter-of-fact character. August Sander, Karl Blossfeldt and Albert Renger-Patzsch represent approaches to photography which, although they still deal with visual subjects in the original sense, have come to be seen and placed in a fully new context by the conceptual-documentary work of the Becher school. With his project *People of the 20th Century* (ill. p. 156/157), August Sander created an oeuvre that combined the quality of constantly detached "objective" representation with a conceptional procedure. Albert Renger-Patzsch, to name one last example here, presented industrial artefacts as icons of the times (ill. p. 150/151). In this he came close to Duchamp and Edward Weston, yet without individualising the items in the way that Duchamp did with the pissoir, or Weston did with the bell pepper. Albert Renger-Patzsch not only maintained a distance to the objects, he also renounced the act of artistic appropriation; he related to the objects in much the same way Karl Blossfeldt did to his plants. They remained purely examples of a species.

During the twenties Erich Salomon was a living witness of political events in Germany and Europe right until the collapse of the Weimar Republic. He exploited the qualities of the new Ernemann camera and managed in inimitable fashion to get up close to politicians without attracting attention. His work became exemplary for a whole century of political photo-journalism. With this, photography was able to assume duties that, prior to the invention of half-tone printing and the resulting possibility of printing photographs, had previously been done by drawing and, above all, steel engraving. This meant that the genre of historical painting, which recorded major political events for all posterity, met its end, and that the pencil drawing survived solely in courtrooms and caricatures. Erich Salomon's work proved that the pho-

tograph is able to give a more authentic and vivid account of political events, and above all that newspapers readers found the credibility of photographic illustrations unsurpassed. Salomon's mastery can be seen time and again in pictures of unobserved moments, and in the trust that politicians showed towards him when they took him on their travels or to their conferences (ill. p. 154/155). Political photo-journalism was transformed by him into a specific genre within the history of photography.

In the Soviet Union photography not only came to assume sociopolitical importance, as in the USA with the Farm Security Administration and in Europe with political reporting, it also became a political instrument and a means of political propaganda. At the same time, however, it joined the other arts as part of the politico-cultural programme, where art was not to be pursued in remove of practical applications, but rather to be of practical and political benefit. Photography became a means of seeing the world anew. Alexander Rodchenko was not solely concerned with the possibilities of a new technology, with making the most of the flexibility and mobility granted by the 35 mm format Leica. This artistic aspect was of paramount importance to Bauhaus photography in Germany. But for the Russian photographers their prime interest was in a new image of the world that matched a new society. Here, photography went hand in hand with fine art, and this in turn with architecture and design. The years of revolution in the Soviet Union were thus accompanied by a dissolution of the boundaries that existed in and between the various areas of fine and applied arts. This idea of the unity of the arts distinguishes the situation in the Soviet Union from that of Western Europe and America, where photography was in the process of laying the foundations of its own specific tradition.

Apart from the developments in photographic traditions and subjects described so far, the early twenties also saw a renewal in the dialogue between photography and fine art. Unlike the situation in the previous century, when photography had emulated painting, there were now artists with a novel approach to photography, far removed from the handed down conventions. Representative of this tendency is Bauhaus photography, which overturned every established rule in the field. Handy 35 mm cameras like the Leica enabled new camera angles and perspectives to be explored and completely new photographic experiences to be created. Non-camera photography investi-

gated the possibility of capturing light patterns directly on plates or paper. A second line of development in art photography arose in the circles loosely connected with the Surrealists. The foremost artists who developed conceptual photography within these circles are Man Ray (ill. p. 124/125), László Moholy-Nagy (ill. p. 134/135), El Lissitzky (ill. p. 120/121), Herbert Bayer (ill. p. 22/23), Christian Schad (ill. p. 160/161), Umbo (ill. p. 185), followed later by Joel Peter Witkin (ill. p. 190) Philippe Halsman (ill. p. 74/75) and Duane Michals (ill. p. 132/133). These developments were accompanied by a number of new techniques, such as the photogram, the photocollage, and the staged photograph, and above all by a change of approach to the technical means of camera, film and photographic paper. Man Ray, who worked with the Dadaists and Surrealists, discovered the fascination exerted by objects, and to this end created paintings and art objects that highlighted the aura that *objets trouvés* develop the moment they are removed from their everyday surroundings and placed in an art context. This Surrealistic principle was of manifest importance to the development of a new angle on photography. As little as Surrealism produced a specific style of painting, all the more so did it seize photography as a medium that met its needs. By placing the object in an unusual context, by isolating or by focusing on the banal, photography proved capable of turning the magic of the object into a powerful theme. Not only could photography be incorporated into painting and act as "citations" of real objects, as done by Picasso, Georges Braque and Kurt Schwitters, the photographic print could also be used to make pure photographic collages, as in the work of László Moholy-Nagy. A further variation was the photogram, in which the shadows of objects are transmitted directly onto photographic paper, a method used among others by El Lissitzky, Man Ray and Christian Schad, and today continued by Floris M. Neusüss (ill. p. 138/139), for instance. The close relationship between picture and reality so unique to photography has above all encouraged artists to employ it for their imaginary visions. At the same time the artists were not simply interested in staking out the limits of photography's ability to give an exact reproduction of reality, but also in exploring the medium and its limits per se. In all of these currents photography is used in a conceptual manner. It not only performs what it is technically able to do – mirroring reality – but simultaneously also reflects on what it is doing.

Photography is currently undergoing a major transformation. It is changing from a medium that traditionally trod its own separate path, away from art history, to a branch of the fine arts. And it is noticeable that young artists are no longer afraid to draw on historical photographical sources and mine them for their art.

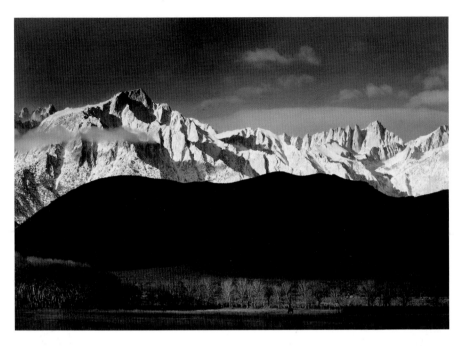

Adams, Ansel

1902 San Francisco
1984 Carmel,
California

An encounter with Paul Strand in 1930 told Ansel Adams, a trained pianist, that photography was his true medium of expression. Strand's concept of pure photography made a lasting impression on Adams and motivated him to clarify his own intentions. In 1932 he formed with other photographers the group "f/64". Members of this group dogmatically practiced a style of photography that emphasized the greatest possible depth of field and the sharpest reproduction of details. Fascinated by the precise rendition capabilities of their medium, they particularly favoured close-ups of individual subjects.

In 1941 Adams created his famous "Zone System", an aid for determining correct exposure and development times for achieving an optimal gradation of gray values. Adams disseminated his photographic ideas and procedures through numerous books and seminars. In 1946 he founded the Department of Photography at the California School of Fine Art in San Francisco. In 1962 he retired to Carmel Highlands. Adams spent a considerable part of his photographic life in America's National Parks. He published over 24 books on them and used his work to generate public interest in the parks, which he supported. *MBT*

▲ Ansel Adams
Sierra Nevada, 1944

Gelatin silver print
23.8 x 33.8 cm
ML/F 1977/24

Gruber Collection

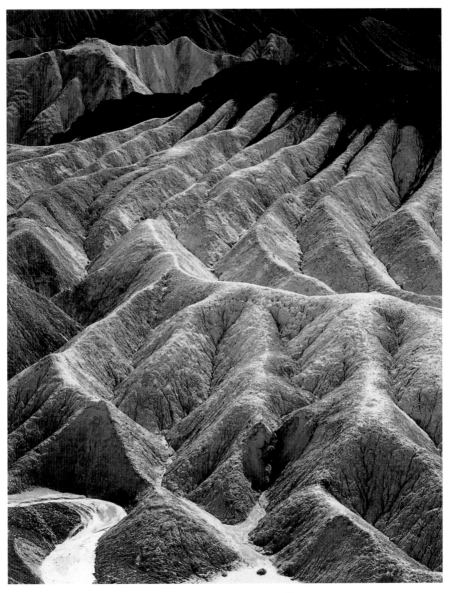

▲ **Ansel Adams**
Zabriskie Point, Death Valley, National
Monument, California, 1948

Gelatin silver print, 23.9 x 19 cm
ML/F 1977/30

Gruber Collection

Arbus, Diane

1923 New York
1971 Greenwich,
New York

Diane Arbus, cult and pivotal figure of the "new" socio-critical wave of documentary photography in the latter half of the 20th century, developed a very immediate visual language to portray not only people on the outer rim of social acceptability, but also the mask-like, comfortably-off citizen of the middle classes. In 1941 she married Allan Arbus, and shortly after the two discovered their interest in photography. They created their first jointly produced advertising shots for her father's dress store in New York, and over the coming years the couple made a success of their fashion photography, working for *Harper's Bazaar*, *Show*, and *Esquire*, among others. From 1955 Arbus studied under Lisette Model, who encouraged her to concentrate on personal shots. From then on her subjects included people both on the street and in their homes, political refugees, midgets, giants, twins, drag artists, nudists, and the mentally ill. For this Arbus first got to know each of her models and gained their consent before photographing them in poses of her choice. Her shots of society's outsiders combine the often dark, disturbing subjects with an objectivity and calm attentiveness that grants the viewer a certain distance to the pictures. Rather than forward any philosophical position in her work, she wished simply to document the world in all its many facets. The result was not pure pictorial docu-

▼ **Diane Arbus**
Patriotic Young Man
with a Flag, NYC, 1967

Gelatin silver print
37,6 x 36,9 cm
ML/F 2000/155

Collection Ludwig

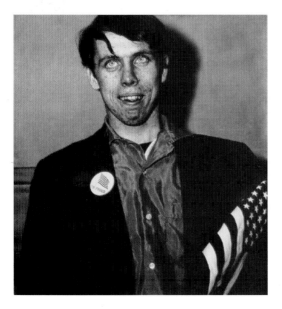

mentation, but descriptions of psychological realities that capture more the private than the social context. Arbus' work had a great influence on the international photography scene of her day, and was the object of much discussion. In 1967 she participated in the "New Documents" exhibition at the Museum of Modern Art, New York, together with Lee Friedlaender and Gary Winogrand. From 1970–1971 she taught at Rhode Island School of Design, New York. In 1971 she decided to put an end to her life. A year later Arbus was the first woman photographer to be ex-

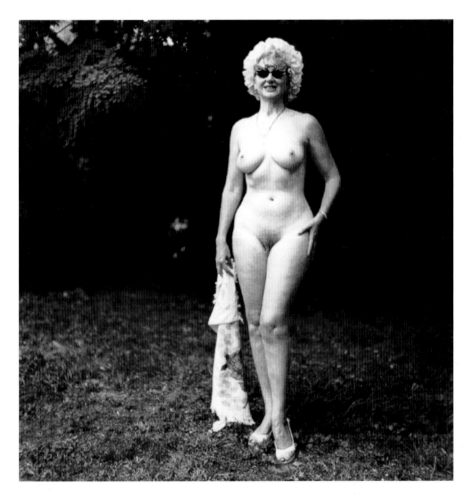

hibited at the Venice Biennale. That same year the New York Museum of Modern Art staged a large touring exhibition, which attracted over 7 million visitors in the USA and Canada. In 1973 a retrospective set out from Japan to tour Western Europe and the West Pacific. The major book of her work, *Diane Arbus: An Aperture Monograph*, 1972, has been reprinted 12 times. *RM*

▲ **Diane Arbus**
Nudist Lady with Swan Sunglasses, 1965

Gelatin silver print
37,6 x 36,9 cm
ML/F 2000/154

Collection Ludwig

Atget, Eugène

1857 Libourne near
Bordeaux
1927 Paris

► Eugène Atget
Corsets, Boulevard
de Strasbourg, Paris,
around 1905

Gelatin silver print
23.3 x 17.2 cm
ML/F 1977/9

Gruber Collection

▼ Eugène Atget
Versailles, Vase in
Castle Park,
around 1900

Albumen print
21.6 x 18.2 cm
ML/F 1977/14

Gruber Collection

Eugène Atget studied at the Conservatoire d'Art Dramatique in Paris, but he left that school without taking his exams. He went on to act in theatres in the suburbs of Paris, where he met the actress Valentine Delafosse, who was to become his life companion. He had already bought himself a camera in those years and was using it. In 1898, noticing that there was a great demand for photographs of the old Paris, Atget took up photography as a profession. He established a system of working and built up a solid circle of collectors. He initially concentrated on Paris, photographing old buildings, street vendors, architectural details, but especially buildings that were threatened with demolition. In later years, he began to cover the suburbs. As soon as some topics were completed, new ones were started, such as *Parisian Residences, Horse Carriages in Paris* and *Fortifications,* which he initiated between 1910 and 1912. Preoccupied with the safe preservation of his collection, Atget offered it to the École des Beaux-Arts in 1920 and received 10,000 francs for his 2621 plates. He then began to produce photographs to serve as subjects for painters, and this took him to the furthest outskirts of Paris. In 1921 he made portraits of a number of prostitutes in the Rue Asselin for the painter André Dignimont.

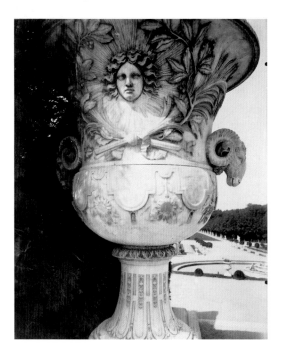

Atget refused to take pictures with any camera other than his old wooden 18 x 24 cm camera. He felt that the Rolleiflex Man Ray had offered him worked faster than he could think. He therefore continued to travel with a lot of luggage. When his life companion died, he began a pause in his work. Shortly after he made a portrait of Berenice Abbott in her studio, Atget passed away on the 4th of August, 1927. *RM*

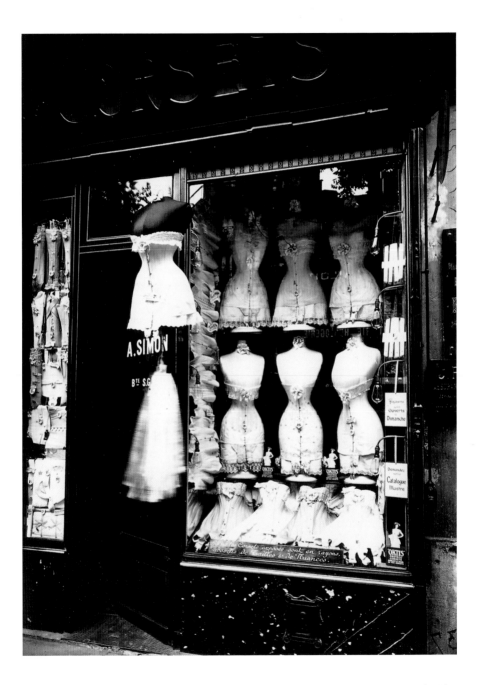

Avedon, Richard

1923 New York
Lives in New York

Richard Avedon is one of the foremost photographers of the 20th century. He has been its restless chronicler for more than 50 years. Although a prize-winning poet at high school, Avedon dropped out in 1942 and joined the Merchant Marines where he took identification photographs of personnel. In the late forties, Avedon became chief photographer for *Harper's Bazaar*. He elevated fashion photography to an art form; he liberated the models from the studied indifference they had always had to show. Avedon's models laughed, danced, played in the rain, and displayed a whole gamut of emotions.

1959 saw the publication of his first photo book *Observations*, which included a text by Truman Capote. In 1963 he photographed the civil rights movement in the South. Avedon's long relationship with *Harper's Bazaar* ended in 1966, when he became staff photographer at *Vogue*. During the late sixties and early seventies Avedon photographed the US anti-war protesters, as well as military leaders and war victims in Vietnam. To mark the fall of the Berlin Wall, Avedon photographed the jubilant crowd on New Year's Eve 1989.

Avedon is also renowned for his portrait work, in which he draws out unexpected facets of people – from the world-famous to the unknown. His large format photographic canvasses, including portraits of members of the "Warhol Factory", the "Ginsberg Family", and the "Mission Council", are milestones in the history of photography. In 1992, Avedon became the first staff photographer for *The New Yorker*.

Avedon has had numerous major exhibitions, including a 1970 retrospective of his portraits at the Minneapolis Institute of Arts: the photographs of his father, Jacob Israel Avedon, at the Museum of Modern Art in New York in 1974, "Avedon: Photographs 1947-1977", which reviewed his fashion photos, "Avedon 1946-1980" at the University Art Museum in Berkeley, California, and "In the American West" at the Amon Carter Museum in Fort Worth in 1985. In 1994, a major retrospective of his work, "Evidence", was staged by the Whitney Museum of American Art in New York before touring the world.

▶ **Richard Avedon**
Dovima with Elephants,
Evening Dress by Dior,
Cirque d'hiver, Paris,
August 1955

Gelatin silver print
24.2 x 19.4 cm
ML/F 1977/39

Gruber Collection

Avedon has published a total of nine books and has received many awards and honours, including the Certificate of Recognition from Harvard University (1986-1987); an honorary doctorate from the Royal College of Art, London, (1989); the Erna and Victor Hasselblad Foundation International Photography Prize (1991), and the International Center of Photography Master of Photography Award (1993), to name but a few.

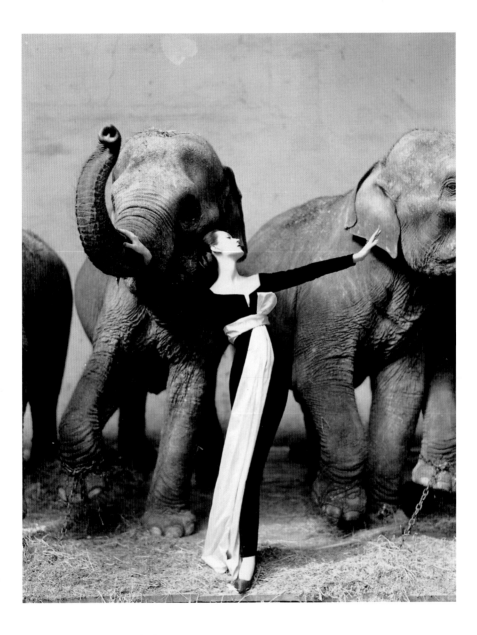

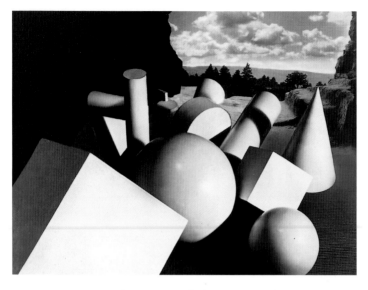

◀ Herbert Bayer
Metamorphosis,
1936

Gelatin silver print
25.5 x 34 cm
ML/F 1977/56

Gruber Collection

Bayer, Herbert

1900 Haag, Austria
1985 Montecito,
California

Herbert Bayer worked as a typographer, advertising artist, photographer, painter, sculptor, architect and even as a designer of office landscapes. The ideals of the Bauhaus, where Bayer acquired his artistic education, are fittingly reflected in the creative activities that he pursued during various periods of his life. From 1921 to 1925 he studied at the Bauhaus in Weimar under Johannes Itten, Oskar Schlemmer, and Wassily Kandinsky. In 1925, he took over the printing and advertising shop of the Bauhaus in Dessau, where he was also responsible for the design of Bauhaus printed publications. That is also when he began working with photography, which became his preferred means of expression in the thirties, before he emigrated to the United States. His photographic work showed him to be not only a representative of the Bauhaus, but above all influenced by the ideas of Surrealism, as in his photomontage *Lonesome Big City Dweller*, in which the artist's hands float in front of the façade of an inner courtyard in Berlin, with his eyes staring at us from the palms of those hands. A ghostly scene, with which Bayer criticized the anonymity of the big city. In his photo-sculpture *Metamorphosis*, Bayer referred to his well-known cover of the Bauhaus magazine of 1928 by once again using geometric bodies such as spheres, cones and cubes. *MBT*

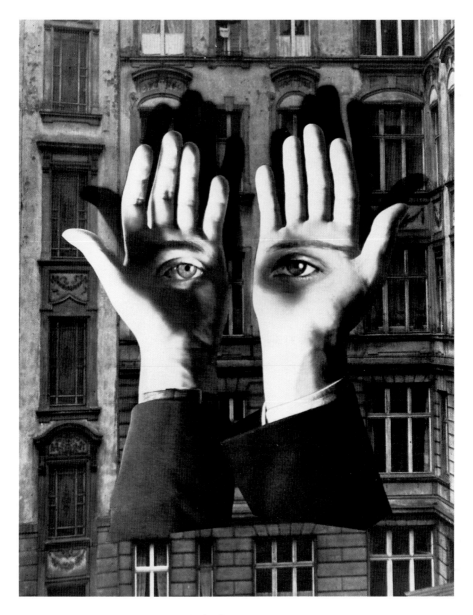

▲ Herbert Bayer
Lonesome Big City Dweller, 1932

Gelatin silver print, 34 x 26.9 cm
ML/F 1977/54

Gruber Collection

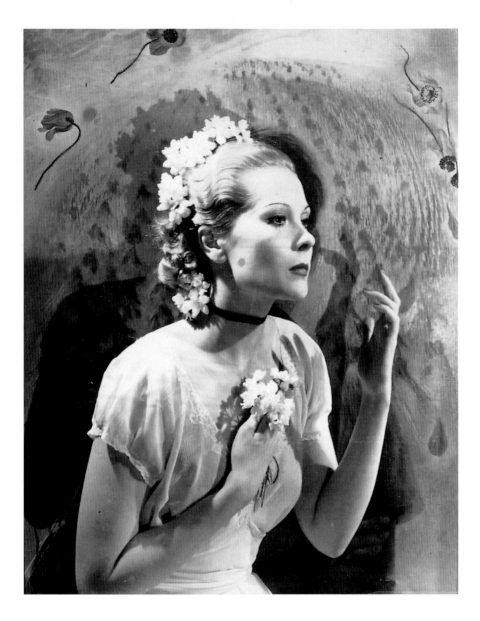

◀ Cecil Beaton
Princess Natalie
Paley, around 1930

Gelatin silver print
23.2 x 19.8 cm
ML/F 1994/91

Gruber Donation

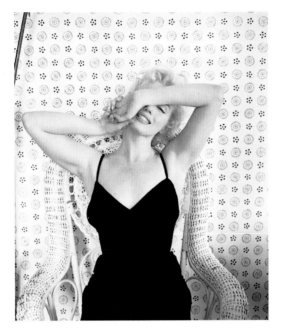

◀ Cecil Beaton
Marilyn Monroe,
1956

Gelatin silver print
25.5 x 20.9 cm
ML/F 1977/58

Gruber Collection

Cecil Beaton's developed early on a predilection for arty, stylized por-trait photographs, inspired by such illustrious predecessors as Edward Steichen. He constructed elaborate backgrounds using showy materials, like mirrors or cellophane, in front of which he posed members of his family in elegant costumes. The photos already hint at his second great talent as a stage and costume designer, which only came to fruition between 1940 and 1970. His first exhibition, in a little-known London gallery in 1926, was an extraordinary success that led to a contract with *Vogue* magazine, for which he remained as a fashion photographer into the mid-fifties. In the Hollywood of the thirties, he created portraits of film stars in the somewhat surreal ambiences of empty film sets. In 1937 Beaton was appointed court photographer of the royal family, and during World War II he was active as a war photographer for the British Ministry of Information. The experience gained during the war years changed the style of his portraits, so that they became clearer and more direct. *TvT*

Beaton, Cecil

1904 London
1980 Broadchalke
near Salisbury

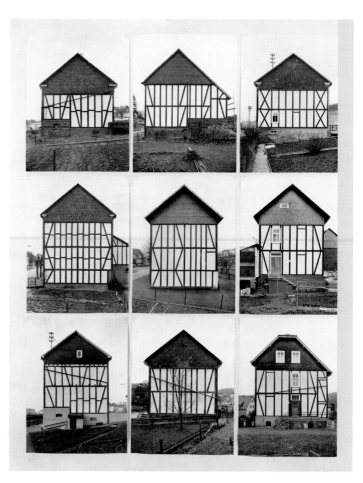

Becher, Bernd

1931 Siegen
Lives in Düsseldorf

Becher, Hilla

1934 Potsdam
Lives in Düsseldorf

The work of Bernd and Hilla Becher is concerned solely with architecture. It concentrates on average buildings and industrial structures that are based on similar basic layouts and designs. Bernd and Hilla Becher have spent over 30 years amassing a multitude of watertowers, storehouses, blast furnaces, winding towers, silos and cooling towers, photographed with strictly defined principles and systematically arranged in sequences. It was only the picture sequences that made the system behind their photographs apparent. Initially regarded as "Anonymous Sculptures", the conceptional aspect of their photographic work was

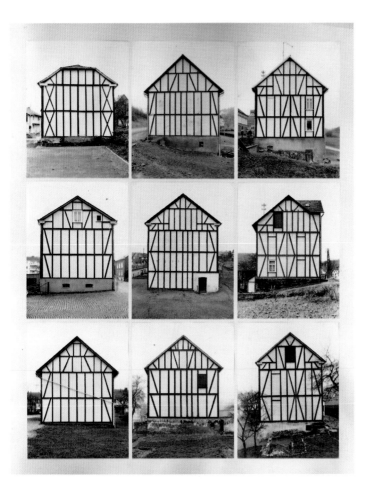

◄ **Bernd and Hilla Becher**
Typology of half-timbered Houses,
1959–1974

*Gelatin silver print
each 40 x 31 cm
in 4 fields of
148.3 x 108 cm*
ML/F 1985/34

Ludwig Donation

only discovered by the art world much later. The recognition of their work sparked attention to the photography of all inanimate objects. The photographic concept of the Bechers continued to be disseminated through their teaching activities. An important effect of that activity was the recognition by the art scene, for the first time, of technically perfect photographic works. Up to then, the art scene had sought to ignore the technical medium by deliberately neglecting the principles of photography. The deciding factor for that change was the connection, by the Bechers, of object and conceptual photography. *RM*

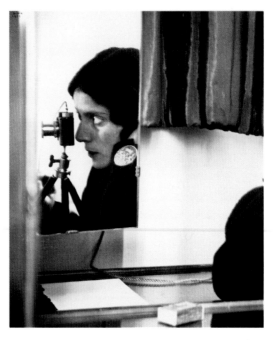

► Ilse Bing
Self-portrait with
Mirrors, 1931

Gelatin silver print
26.6 x 29.8 cm
ML/F 1988/178

Bing, Ilse

1899 Frankfurt/Main
1998 New York

Ilse Bing's contacts with the avant-garde artists of Frankfurt soon began to influence her photography, which clearly reflected the new way of seeing of the twenties in the choice of subjects and camera angles. She became interested in experimental photography, worked with daring angles and croppings, with reflections and the play of shadows. One of her most famous photographs is her self-portrait of 1931, in which she ingeniously combined a profile and a frontal view of herself using mirrors. Impressed by an exhibition by Florence Henri, she moved to Paris in 1930. There she worked from 1931 onwards as a freelance photojournalist, architectural photographer, and advertising and fashion photographer for magazines. In 1936 she travelled to New York, where her work was received enthusiastically. She emigrated to the United States in 1941 and began working exclusively in colour in 1957. Yet it is her black-and-white photography of the thirties and forties that brought her the greatest acclaim. Ilse Bing also was a sought-after guest lecturer. In Germany, she faded somewhat from the public eye, but was rediscovered in the mid-eighties. The Museum Ludwig in Cologne first displayed her work in 1987 as part of the exhibition "German Photographers". *RM*

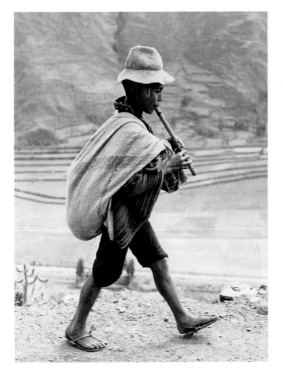

◄ **Werner Bischof**
Boy Playing the Flute
near Cuzco, Peru,
1954

Gelatin silver print
39.8 x 30.1 cm
ML/F 1977/84

Gruber Collection

Werner Bischof is regarded as one of the foremost international photo-journalists of the post-war era. In 1942, he joined the editorial staff of the Swiss magazine *Du*, working primarily as a fashion photographer. In 1945, he travelled all over Europe to document the destruction left by war. He joined the "Magnum" group in 1949. Although the change to photojournalism forced Bischof to alter his work methods, he nonetheless retained his sensitivity for technical perfection. In 1951 he received an assignment from the American *Life* magazine to travel to the hunger-stricken areas of Bihar and to north and central India. The resulting photographic essay *Famine in India* brought Bischof his first international success. In later years Bischof travelled to places such as Japan, Hong Kong, Indochina and Korea, where he was fascinated by children who, despite poverty and war, demonstrated remarkable resilience. One of Bischof's best known children's photographs is *Boy Playing the Flute near Cuzco, Peru*. Bischof made that photograph only a few days before his fatal accident in the Peruvian Andes. *MBT*

Bischof, Werner

1916 Zurich
1954 Peru

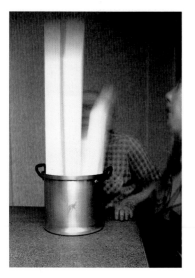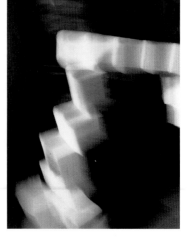

Blume, Anna

1937 Bork
Lives in Cologne

**Blume,
Bernhard
Johannes**

1937 Dortmund
Lives in Cologne

After reading philosophy at the University of Cologne and fine art at the Düsseldorf Academy, Bernhard Johannes Blume developed his photo-actionistic-metaphorical system of "Ideosculpture" – the pictorial staging of everyday encounters. He began with drawings, photographic sequences and installations (furniture, vases etc.), but his large, spectacular series of photographs *Oedipal Complications?* (Ludwig Collection, Vienna) in 1977 marked the beginning of the exclusive production of such large sequences of photos. The sequences were done in an actionistic and photographic collaboration with his wife, Anna Blume. By 1984 the series *Wahnzimmer* established them on the international scene. It was followed by the series *Küchenkoller, Mahlzeit* (1985), *Trautes Heim* (1985/86) and *Vasenekstasen* (1986), as well as the large sequences of photos from the series *Im Wald* (1982–1990) and *Transzendentaler Konstruktivismus* (1994/95). 1999 saw the completion of their large-scale digital print series *Prinzip Grausamkeit,* based on polaroids taken between 1995 and 1998.

Anna and Bernhard Blume got to know each other while studying at the Düsseldorf Academy. Anna taught until 1985 art and handicrafts at a number secondary schools in Cologne, before working as a visiting lecturer. It is she who is largely responsible for the conception and realization of their large joint exhibition installations. In 1987 Bernhard

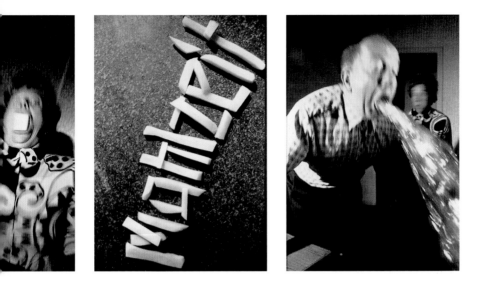

Johannes was elected professor at the Hochschule für Bildende Künste in Hamburg.

Most especially the Blumes' black and white series hold up a mirror to the daily madness of "home sweet home", the absurdity of middle class and petty bourgeois institutions, habits and rituals. The accompanying aesthetics are plunged into "chaos" by the rigid formalization of the Blumes' pictures and their ironic, disjointed actionism. The apparent security of this life world becomes easy to see through amidst the scenes of breakdown that they stage.

Since the seventies, and above all since the eighties and the commencement of their collaboration, the two photographers have also produced extensive series and collages using Polaroids. These chiefly consist of "mutual parodistic photo-portraiture", in an often painful combination with a variety of brightly coloured plastic objects, which come to fuse with the various halves of the portraits during the direct or digital collage procedure. In 1990 the artists wrote in this connection in one of their catalogues: "[...] While searching for a mutual ego during our photographic quests, there emerged a different reality with an opposing meaning: the VERY OBJECTS are this I and WE! The form, colour and aesthetics of such things are our fate! Indeed, the objects are related, if not identical, to us! I, YOU, HE, SHE, IT, WE, YOU, THEM." *RM*

▲ Anna and Bernhard Johannes Blume
Bon appétit!, 1986

Gelatin silver print
5 parts, each
126.8 x 91.1 cm
ML/F 1988/19 I-V

Hypo-Bank Donation

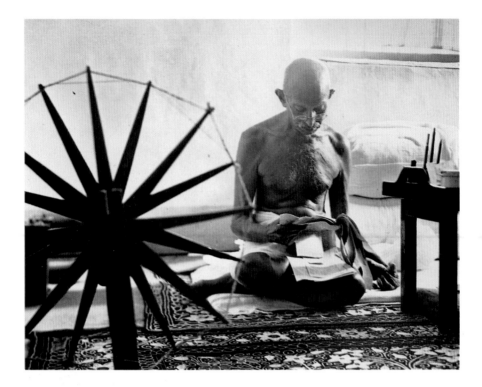

Bourke-White, Margaret

1904 New York
1971 Stanford, Connecticut

▲ Margaret Bourke-White
Mahatma Gandhi, 1946

Gelatin silver print
26.8 x 34.2 cm
ML/F 1977/92

Gruber Collection

The work of Margaret Bourke-White has become symbolic of American political and social-minded photojournalism. Interested mostly in industrial photography since 1928, she received her first major assignment from *Fortune* magazine in 1930, travelling to the Soviet Union, where she became the first foreign reporter to receive permission to photograph Soviet industrial installations. Margaret Bourke-White was one of the founding members of *Life* magazine in 1936, on which her photograph of Fort Peck Dam, then the largest hydroelectric power plant in the world, was used as the first cover picture. During the Second World War, Margaret Bourke-White served as a photographic war correspondent. After the capitulation of Germany, her shocking photographs of liberated concentration camps attracted world-wide attention. In 1946 she travelled to India on assignment from *Life* to document that country's struggle for freedom. In her photograph of Gandhi, she emphasized the spinning wheel, symbol of India's independence,

► **Margaret Bourke-White**
Miners, Johannes-
burg, 1950

Gelatin silver print
24.1 x 17.6 cm
ML/F 1977/90

Gruber Collection

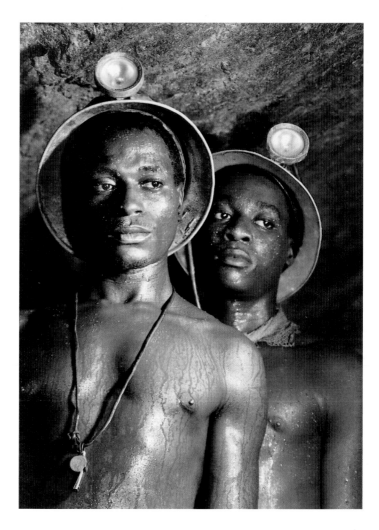

by placing it dominantly in the foreground. At the end of 1949, *Life* magazine sent Margaret Bourke-White on assignment to South Africa for a few months. There, in a gold mine near Johannesburg, at a depth of nearly 5000 feet (1500 m) and in blistering heat, she made the photograph of the two black miners drenched in sweat – a photograph that she herself declared to be one of her favourite pictures. *MBT*

Brassaï
(Gyula Halász)

1899 Brasso, Hungary
(now Brasvo, Roma-
nia)
1984 Beaulieu-sur-
Mer, South of France

Gyula Halász, known since 1932 by his pseudonym Brassaï (derived from "de Brasso", his place of birth), came to photography through self-education. He first studied art in Budapest and Berlin, and soon he was active in circles that included László Moholy-Nagy, Wassily Kandinsky and Oskar Kokoschka. In 1924 he went to Paris as a journalist. There he became acquainted with Eugène Atget in 1925, whose photographs were to become a constant model for his later work. During his lengthy wanderings through night-time Paris, Brassaï began, in 1930, to record the city's deserted streets and squares. The results were published in 1932 in his famous book *Paris de Nuit*. Apart from the aesthetic fascination of

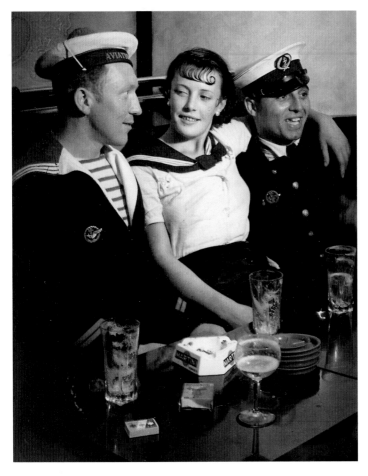

◀ **Brassaï**
Sailors' Love, 1932

Gelatin silver print
29.3 x 22.8 cm
ML/F 1977/106

Gruber Collection

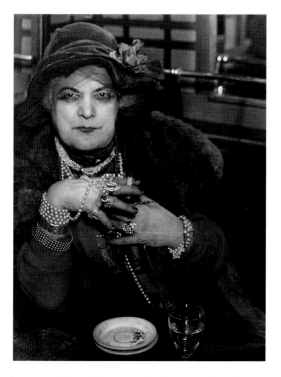

▶ **Brassaï**
The Prostitute Bijou
in the Bar de la
Lune, Montmartre,
Paris, 1933

Gelatin silver print
30 x 23 cm
ML/F 1977/109

Gruber Collection

the mysterious and stage-set-like architecture, the photographer also relished the technical challenge that the extreme lighting conditions posed his night-time photographs. During these nightly excursions, Brassaï was fascinated by how society amused itself, and recorded the city's night owls in bars and n the streets. Among the best known photographs of this period is *The Prostitute Bijou*. However, the publication of that photograph in his book *Paris de Nuit* incensed the old lady, and it took a few banknotes to placate her.

In 1932 Brassaï discovered the graffiti on the walls of Paris, and he covered this subject for many years to come. Through his contributions to the Surrealist periodical *Minotaure* during the thirties, Brassaï became acquainted with many writers, poets and artists of Surrealism. He began to work for *Harper's Bazaar* in 1937, and supplied that magazine with many photographic essays on famous literary personalities and artists. In 1962, after the death of Carmel Snow, the publisher of *Harper's Bazaar*, Brassaï gave up photography altogether. *MBT*

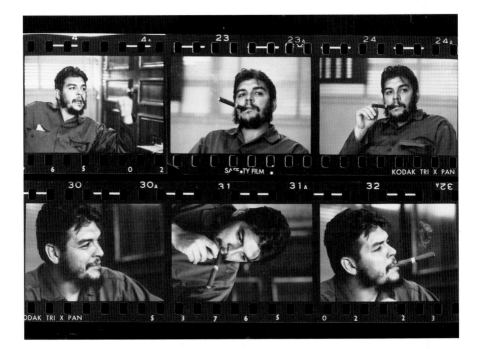

Burri, René

1933 Zurich
Lives in Paris

▲ René Burri
Che Guevara,
Havana, Cuba, 1963

Gelatin silver print
23 x 30
(each 6 x 9.3) cm
ML/F 1984/14

Gruber Donation

From 1950 to 1953, René Burri studied photography under Hans Finsler and Alfred Willimann at the Arts and Crafts College in Zurich. In 1953, thanks to a scholarship, he was also able to take up motion pictures. He made small documentary films and, still in 1953, he was the camera assistant to Ernest A. Heininger for one of the first Cinemascope films about Switzerland. Two years later Burri joined that agency. During the years that followed, he travelled all over the world. The spectrum of his subjects ranged from political reportage to landscapes, architecture, industry and city reports all the way to portraits of prominent artists, architects, and literary personalities. One of his most famous portraits is that of Che Guevara, which became a symbol of the Cuban revolution. During 1960, Burri worked mostly in Germany preparing material for his book *The Germans*, a compilation of Burri's photographs and texts about the Germans by various authors. In 1965 Burri participated in the establishment of "Magnum Films". Together with Bruno Barbey, he opened the Magnum Gallery in Paris in 1982. He has been the art director of the Swiss magazine *Schweizer Illustrierte* since 1988. *MBT*

Harry Callahan initially studied engineering at Michigan State University, and from 1934 to 1944 he worked at Chrysler Motors. In 1938 Callahan became interested in photography. Having attended a lecture by Ansel Adams in 1941, and after seeing one of his exhibitions, Adams became Callahan's great role model. Callahan then began making photographs with a large-format camera. Beginning in 1946, he taught photography at the Chicago Institute of Design, and in 1949 he took over as director of its Department of Photography. During that period, he became friends with Hugo Weber, Mies van der Rohe, Aaron Siskind and Edward Steichen. In 1961, Callahan became the director of the Department of Photography of the Rhode Island School of Design in Providence, RI.

In his photographic work, Callahan showed a predilection for detail shots, to which he often imparted an abstract effect through tight cropping. He liked to experiment with double exposures, and he also used over-exposures to create a graphic effect in his photographs. *MBT*

Callahan, Harry

1912 Detroit,
Michigan
1999 deceased

▲ **Harry Callahan**
Nature, 1948

Gelatin silver print
17.9 x 24.8 cm
ML/F 1984/16

Gruber Donation

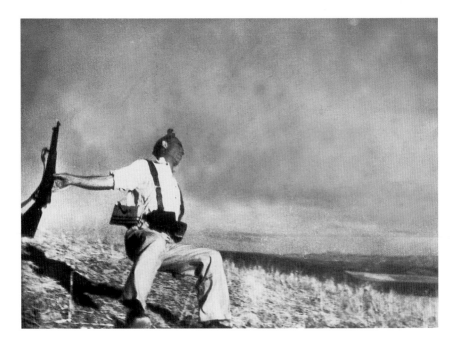

Capa, Robert
(André Friedmann)

1913 Budapest
1954 Thai-Binh,
Vietnam

▲ Robert Capa
Death of a Spanish
Loyalist, 1936

Gelatin silver print
24.6 x 34 cm
ML/F 1977/132

Gruber Collection

Robert Capa, born André Friedmann, studied political science at the University of Berlin from 1931 to 1933. He was a self-taught photographer, and in 1931 he started working as a photo lab assistant at Ullstein (a publishing house). In 1932 and 1933 he worked as a photo assistant at Dephot (Deutscher Photodienst, a news agency). In 1933 he emigrated to Paris, where he changed his name to Robert Capa and where he began working as a freelance photographer. His photographs of the Spanish Civil War attracted attention to his name in Paris. His very first series already included the picture entitled *Death of a Spanish Loyalist*, which to this day is still his most famous and much discussed photograph. From then on he concentrated on being a photographic war correspondent. He travelled to China, Italy, France, Germany, and Israel. On the 25th of May 1954 he was fatally injured in Thai-Binh, Vietnam. His death was the tragic consequence of his own motto "If your pictures aren't good enough, you aren't close enough". His talent for pointedly conveying the feelings and suffering of people in civil wars or rebellions in a single picture earned him great admiration.

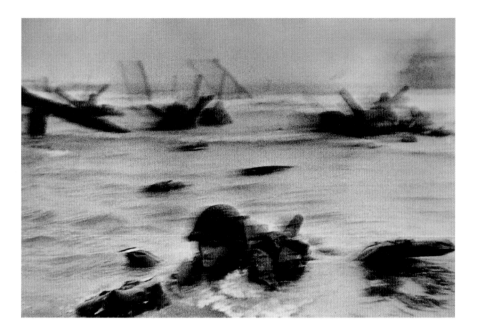

A quality that transpires throughout Capa's pictures is his fascination for the fine edge along which humans proceed between the will to live and the urge for self-destruction. His obsession with his work made him the most famous war correspondent of the Twentieth Century. But Capa did not just set standards for photography and perform exemplary work. His work is also a manifesto against war, against injustice and oppression. The Robert Capa Gold Medal Award has been presented in his honour since 1955. The International Fund for Concerned Photography was initiated by him. His brother, Cornell Capa, founded the International Center for Photography in New York partly for the purpose of preserving the work of Robert Capa and for making it accessible to the public. *RM*

▲ **Robert Capa**
D-Day, 1944

Gelatin silver print
22.7 x 34.1 cm
ML/F 1977/115

Gruber Collection

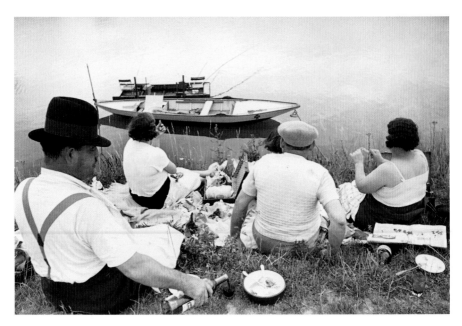

Cartier-Bresson, Henri

1908 Canteloup
Lives in Paris

▲ Henri Cartier-Bresson
Sunday on the Banks of the Marne, 1938

Gelatin silver print
27.5 x 39.9 cm
ML/F 1977/141

Gruber Collection

▶ Henri Cartier-Bresson
Rue Mouffetard, Paris, 1958

Gelatin silver print
37.2 x 25.1 cm
ML/F 1977/126

Gruber Collection

Henri Cartier-Bresson is a living legend. Hardly any other photographer has been cited so often as exemplary of one of the great capabilities of photography: capturing a moment. In Cartier-Bresson's view, it is not just any moment, as it is in 99% of the millions of pictures made every day, for him it is "le moment décisif", the decisive moment that expresses the essence of a situation. This photographer worked for nearly all the great international newspapers and magazines of the world. Together with Robert Capa, David "Chim" Seymour and George Rodger, he founded the "Magnum" group, and his travels took him to India, Burma, Pakistan, China, Indonesia, Cuba, Mexico, Canada, Japan and the former USSR. He authored many books illustrated with his photographs, among them *The Decisive Moment, Changing China*, and *The World of Henri Cartier-Bresson*. In 1970 he married the photographer Martine Franck. Today Cartier-Bresson no longer takes pictures, having returned to his original passion of painting and drawing. *RM*

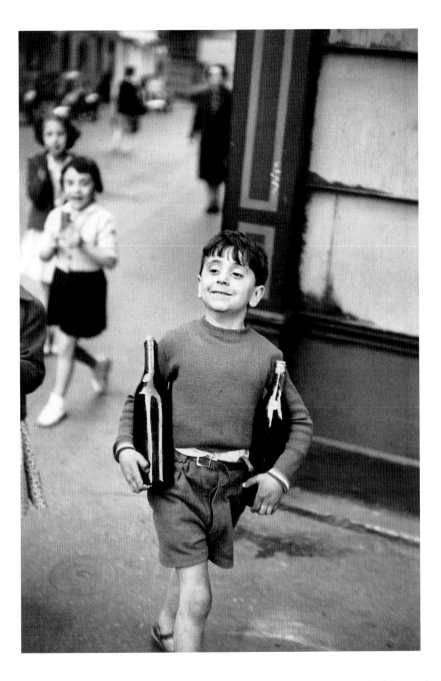

Chargesheimer
(Karl Heinz
Hargesheimer)

1924 Cologne
1971 Cologne

Karl Heinz Hargesheimer attended the College of Commerce in Cologne, where his teachers noticed his anti-National-Socialist attitudes. In 1942 he had a lobe of one of his lungs inactivated in order to evade military conscription. Based on his abilities, he was then accepted into the photographic curriculum of a Cologne factory school without the respective prerequisites. In 1948, on the occasion of a story for the magazine *Stern*, he gave himself the name Chargesheimer. From 1950 to 1955 he was a lecturer at the BiKla School in Düsseldorf. In 1956, L. Fritz Gruber exhibited his work at Photokina. In 1957 he started a series of photo books, which all caused a furore: *Cologne intime, Unter Krahnenbäumen, In the Ruhr Region, Romanesque Style on the Rhine, People at the Rhine, Berlin – Pictures of a Big City* and *Interim Balance Sheet*.

This series concluded in 1962, and Chargesheimer dedicated himself to the stage. He was a stage designer and director and busied himself with kinetic sculptures, his meditation mills. In addition, he returned to his abstract photography and light graphics, with which he attempted to break into the art trade, but it was not until the eighties that the significance of this experimental photography was recognized.

◄ **Chargesheimer**
Konrad Adenauer,
1954

Gelatin silver print
29.2 x 33.8 cm
ML/F 1977/172

Gruber Collection

▶ Chargesheimer
Morning in the
Nightgown Quarter,
1956

Gelatin silver print
29.6 x 23.7 cm
ML/F 1980/386

These successes had no bearing on the fact that he became embroiled in a personal crisis that was also heavily fanned by social developments. His book, *Cologne 5:30 AM*, in which he focused intensely on the spread of concrete in his home town of Cologne from the point of view of a conceptional city portrait, even rejecting a foreword already written by Heinrich Böll, became his legacy. He died under mysterious circumstances on New Year's eve in 1971. In 1978, his estate was donated to the Museum Ludwig in Cologne, and his meditation mills and light graphics followed in 1989. The scholarship for the furtherance of photography sponsored by the city of Cologne has been named after him since 1986. Chargesheimer is now recognized internationally for his significance as an avant-gardist. *RM*

◀ A. L. Coburn
Semi-nude,
around 1905

Photogravure
8.3 x 10.3 cm
ML/F 1984/24

Gruber Donation

▶ A. L. Coburn
St. Paul's Cathedral
from Ludgate Circus,
around 1905

Photogravure
38.2 x 28.6 cm
ML/F 1977/183

Gruber Collection

**Coburn,
Alvin Langdon**

1882 Boston
1966 Colwyn Bay,
North Wales

Alvin Langdon Coburn belongs to the generation of photographers who brought about the change from the pictorialism of the 19th century to an avant-garde-oriented style of photography.

It was during a visit in 1899 to a distant cousin in London, art photographer Fred Holland Day, that Coburn became definitely fascinated with photography. As early as 1902 he opened his own studio in New York. There Coburn became acquainted with Alfred Stieglitz, in whose magazine *Camera Work* he published some of his photographs as photogravures. Through the circle of artists around Stieglitz, Coburn soon became familiar with the avant-gardistic trends of the art. Inspired by that trend, he began to explore new forms of expression with photography. He experimented with extreme perspectives and developed a strong interest in structures and abstract formations. In 1912 he left New York and went to Great Britain, where he remained to the end of his days. There he had friendly contacts among members of the English group of cubists founded by Ezra Pound and called "Vorticists". This connection inspired Coburn's "Vortographs", in which he achieved a cubist fragmentation of forms by using reflecting prisms.

In addition to his avant-garde creativity, Coburn also made a name for himself with portraits of famous contemporary personalities, which he published in 1913 and 1922 in his two volumes entitled *Men of Mark*. MBT

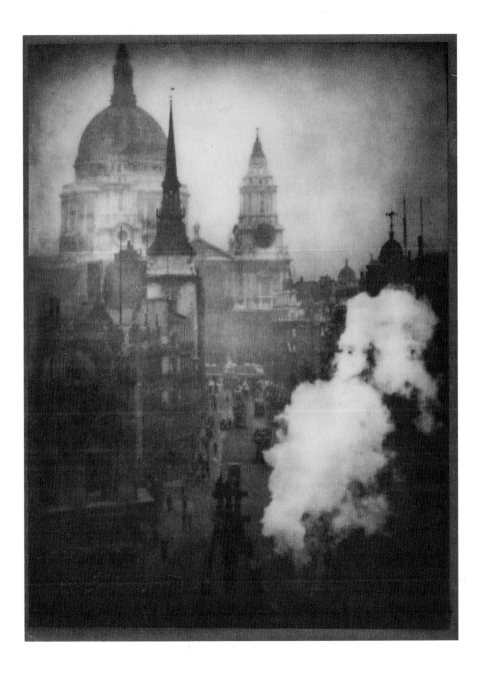

**diCorcia,
Philip-Lorca**

1953 Hartford,
Connecticut
Lives in New York

Philip-Lorca diCorcia attended Yale University, New Haven, and the School of the Museum of Fine Arts in Boston. After an unsuccessful attempt to find employment in the film trade, he worked in New York as a photographic assistant to professional photographers before becoming in 1984 a freelance photographer for magazines such as *Esquire, Fortune, Condé Nast Traveller* and *Details*.

By the late seventies he had already found his photographic means of expression, which have remained his hallmark to this day. For one or two years he photographed his family, which culminated Christmas 1978 in a picture he shot of his brother Mario in the kitchen. While seeming quite plain and simple, the picture was in fact the product of careful staging and additional lighting. This picture assumed model status for all of his later work, not only regarding his working methods, but also his artistic interests.

DiCorcia's subjects are always banal. But he has come up with techniques that transform their commonplace nature into something extraordinary and mysterious. Things that seem quite chance and incidental are turned into metaphoric images by means of tight composition and above all the use of lighting. During the first years of his work, Philip-Lorca diCorcia staged such everyday scenes in his own environs. He installed artificial lighting and took numerous Polaroids as trial shots before taking the final photograph. He recruited his models from his own circle of friends. They allowed him to fix every detail, and also worked in the way he wanted. In the early nineties diCorcia travelled frequently to Los Angeles in order to photograph the prostitutes and the gay scene on Santa Monica Boulevard. With this series he began to merge his earlier conception of stagings with a documentary approach, which ultimately led him to the street pictures, in which he took active control without, however, the "actors" having any awareness whatsoever of being involved in the scenario they had entered. DiCorcia developed a method for transferring the principles of staged studio photography to the street, while taking the inspiration for his subject matter from "street photography". A cleverly devised network of flash units, camera positions and camera angles created as it were a photo-snare for passers-by, who suddenly found themselves on a stage and transformed into the leads, without knowing what role they were playing. In this way Philip-Lorca diCorcia developed a method that combined the idea of the "decisive moment" found in Henri Cartier-Bresson, say, with the stagings of a Jeff Wall.

DiCorcia does not view photography as the essence of a captured moment, but rather as the product of careful planning and foresight. This demands not only the exact observation of everyday life during the preparatory phase, but equally a study of the methods that can secure what is observed, in picture form, by means of photography, and can reconstruct *a posteriori*, as it were, a moment that has been observed and considered remarkable in the picture. And all of this within the framework of a broadly specified method, which is, after all, likewise a valid concept for the viewer and the way the viewer sees images. *RM*

▲ **Philip-Lorca diCorcia**
N. Y., 1983

c-print, 76 x 101,4 cm
ML/F 1999/63

DuMont-Schütte Donation

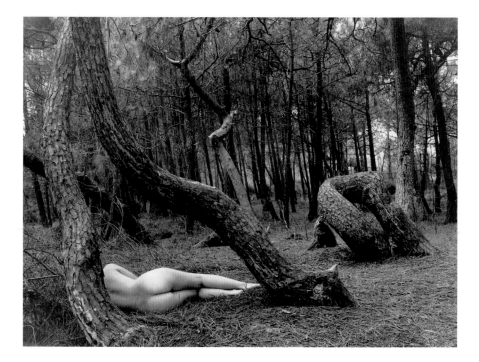

Dieuzaide, Jean

1921 Grenada-sur-
Garonne
Lives in Toulouse

▲ Jean Dieuzaide
Nude in the Woods,
1975

Gelatin silver print
30.3 x 40.3 cm
ML/F 1995/120

Uwe Scheid
Donation

Jean Dieuzaide's career as a photographer began on the 19th of August 1944, when he took pictures of the liberation of his home town of Toulouse. In 1945, he began working as a photojournalist for various newspapers and weekly magazines. In 1951 he settled down as a photographer in Toulouse. His famous picture of the great Surrealist *Dalí in the Water, Cadaquès,* was made during a 1953 trip to Spain.

During the fifties, Dieuzaide discovered his predilection for the structures of things. His close-up pictures of sea mud, in which the photographer found fascinating formations, became his most famous photographs of this genre. In 1974 he published this series under the title *My Adventure with Tar.* In 1963 Dieuzaide was among the founders of the "Libre Expression" group, which believed in "subjective photography" and in the ideas of Otto Steinert. Until 1981, Dieuzaide operated a gallery in Toulouse, in which he provided a display forum for members of the "Libre Expression" group. Dieuzaide closed his studio in 1986. *MBT*

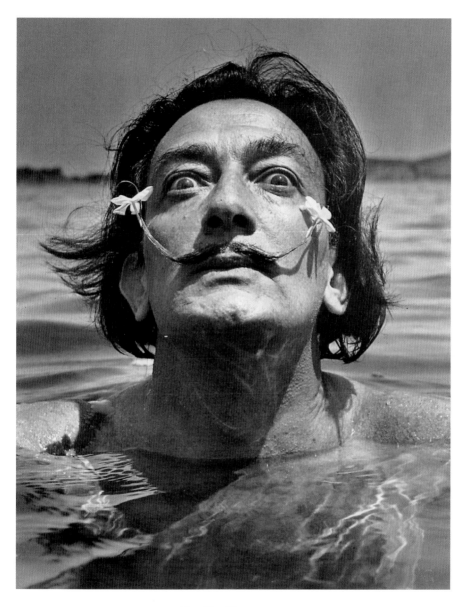

▲ Jean Dieuzaide
Dalí in the Water, Cadaquès, 1953

Gelatin silver print, 31 x 24.5 cm
ML/F 1984/31

Gruber Donation

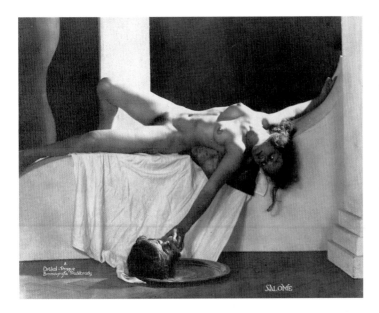

◄ František Drtikol
Salome, 1923

Bromoil print
22.8 x 28.7 cm
ML/F 1984/34

Gruber Donation

► František Drtikol
Nude, around 1920

Gelatin silver print
11.8 x 8 cm
ML/F 1993/172

Gruber Donation

**Drtikol,
František**

1883 Príbram,
Bohemia
1961 Prague

František Drtikol was one of the most famous photographers of the twenties and thirties in the former Czechoslovakia, and he also enjoyed an international reputation. His work was largely forgotten after he gave up photography in 1935, only to gain renewed recognition in the early seventies.

From 1901 to 1903, Drtikol enjoyed a well-founded education at the Bavarian State Institution for Photography in Munich. In 1910, after completing his military service and after spending three years in Príbram, Drtikol went to Prague, where he experienced public recognition of his work for the first time. Drtikol specialized in portraiture and nude photography, showing himself stylistically influenced by Romanticism and Symbolism. It was during this period that the feminine figure of Salome first appeared in his photographs, which continued to fascinate him during his entire work. During the twenties, Drtikol's style underwent significant changes: he began to emphasize and arrange space with man-sized geometrical forms, he developed the creative possibilities of light into virtually expressionistic dramaturgy, and he reduced his nudes to torsos or individual limbs. *MBT*

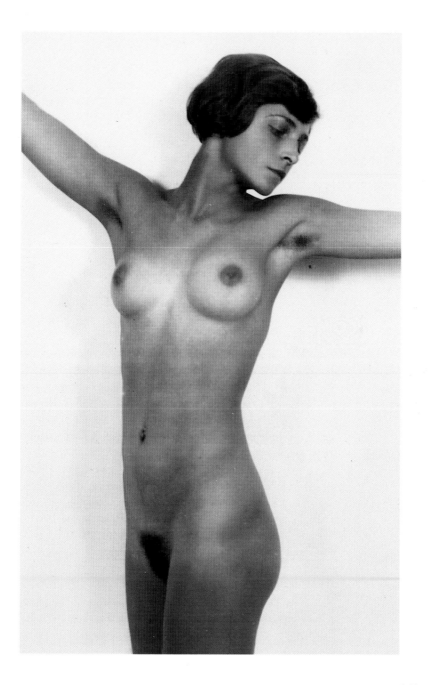

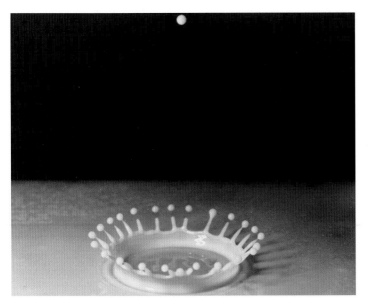

◄ Harold
E. Edgerton
Milk Drop, 1936

Gelatin silver print
39.5 x 49.9 cm
ML/F 1977/229

Gruber Collection

Edgerton,
Harold E.

1903 Fremont,
Nebraska
1990 Boston

Harold E. Edgerton studied at the University of Nebraska from 1921
to 1925 and at the Massachusetts Institute of Technology in Cambridge,
MA from 1926 to 1927, where he began to teach in 1928. As an inde-
pendent photographer he developed stroboscopic photography of
high-speed kinetic action. A large number of his photographs became
milestones of "high speed photography" and he received numerous
international awards.

Stroboscopic photography is a technique for capturing and depict-
ing kinetic action and timed events in distinct steps. Edgerton used
strobe flash for recording fast action on film. The photographs were
made in a darkened room, using numerous exposures per second.
This also became a scientific tool, because it made the fine details
of such fast-occurring events become visible for the first time.

One of Edgerton's most famous photographs is his *Milk Drop,*
which shows the delicate, crown-shaped form created by a milk drop
when it strikes a thin layer of milk on a plate. A physical event that is
familiar to scientists is transformed into a liquid sculpture that can
only be made visible by means of Edgerton's photographic technique.
UP

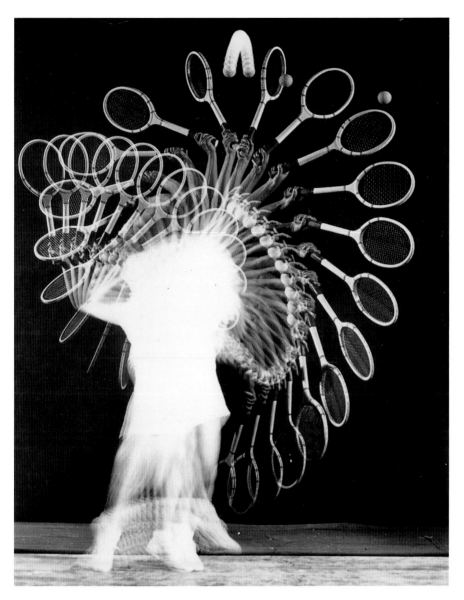

▲ Harold E. Edgerton
Tennis Player, 1938

Gelatin silver print
24 x 19 cm
ML/F 1977/224

Gruber Collection

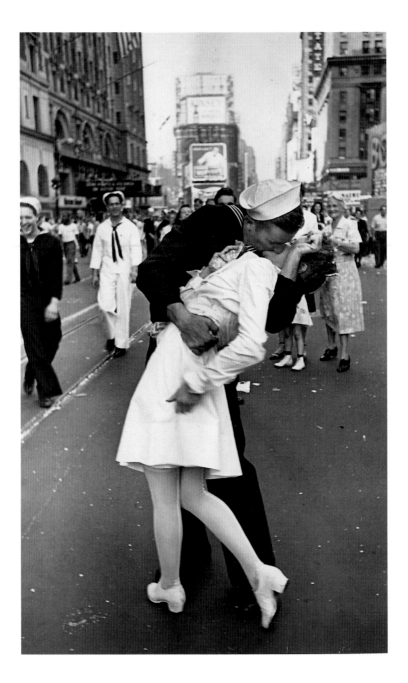

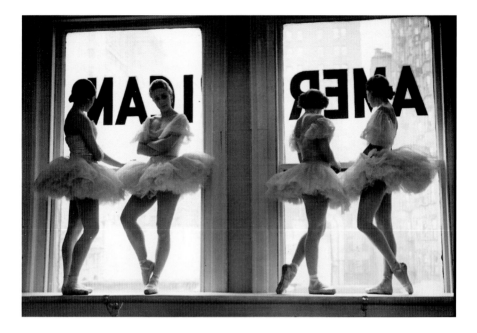

Alfred Eisenstaedt's first assignment, a photographic report of the awarding of the Nobel Prize to Thomas Mann in 1929, already earned him great recognition. During those years he made many portraits that became famous, of such personalities as, among others, Marlene Dietrich, George Bernard Shaw, but also Joseph Goebbels, Hitler and Mussolini. In addition, he also produced a report about the war between Italy and Ethiopia. He worked for the *Berliner Illustrirte Zeitung* and other tabloids in Berlin and Paris. After emigrating to America in 1935, he began working for *Harper's Bazaar, Vogue*, and *Town and Country*, and then from 1936 on, for *Life*. He shot over 90 cover pictures and undertook over 2500 assignments for *Life*. It was chiefly Eisenstaedt's photographs of people that earned him a place in photographic history. One of his most famous photographs is *V-Day*, a snapshot of a passionate kiss during a victory parade of sailors in Times Square at the end of World War II. Eisenstaedt is regarded as a pioneer of available light photography, because early on he dispensed with flash photography. Eisenstaedt was honoured with numerous international awards and he counts among the most published photojournalists in the world. *TvT*

Eisenstaedt, Alfred

1898 Dierschau, Germany
1995 Oak Bluffs, Massachusetts

▲ **Alfred Eisenstaedt**
American Ballet, 1938

Gelatin silver print
16.2 x 24.1 cm
ML/F 1977/237

Gruber Collection

◄ **Alfred Eisenstaedt**
V-Day, 1945

Gelatin silver print
24 x 15 cm
ML/F 1977/242

Gruber Collection

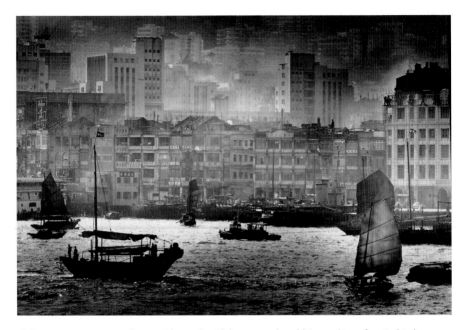

Elsken,
Ed van der

1925 Amsterdam
1990 Edam

▲ **Ed van der Elsken**
Hong Kong, 1960

Gelatin silver print
31 x 40.5 cm
ML/F 1988/79
Gruber Donation

▶ ▲ **Ed van der Elsken**
Girl Refugee,
Hong Kong, 1960

Gelatin silver print
15.8 x 23.4 cm
ML/F 1977/252
Gruber Collection

▶ **Ed van der Elsken**
Durban, South Africa,
1960

Gelatin silver print
23.9 x 30.2 cm
ML/F 1977/255
Gruber Collection

Dutchman Ed van der Elsken completed his studies of art in his home town, later moving to Paris to work as a freelance photographer. He also became a correspondent for a Dutch newspaper. Many of this politically active photographer's socio-critical pictures and films were made during a trip around the world. At first, he worked only in black-and-white, taking up colour later on. In a photographic series about jazz, created between 1955 and 1961, he did not use flash illumination, because he considered it important to preserve the atmosphere and the emotions of the moment in natural light conditions. Elsken published *Sweet Life* in 1963, along with numerous photographic books about Amsterdam, Japan, and China. Elsken expressed the drama of social injustice in a pictorially concentrated manner with photographs like the one of the careworn, strained face of a Chinese girl, or the one of the South African apartheid situation. Both with genre studies of the subculture of Amsterdam as well as the photographic short story *Love on the left Bank,* Elsken expressed his interest in people on the margins of society, who are never shown in representative reports about a country. *LH*

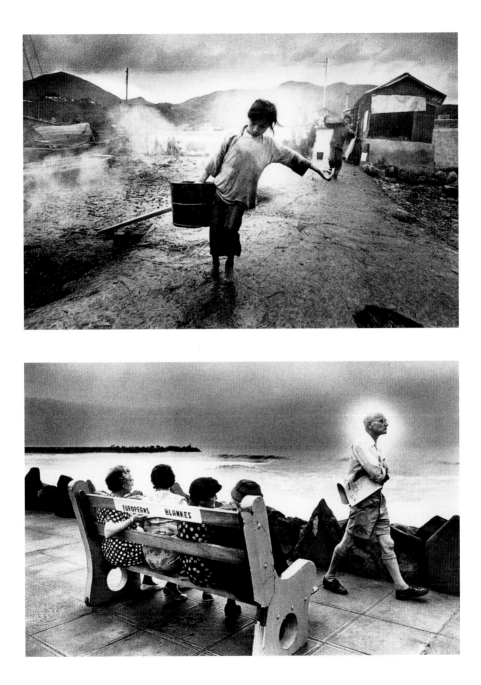

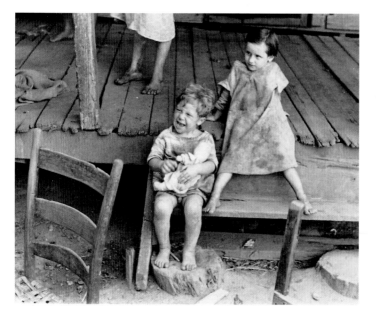

◀ **Walker Evans**
Children in Alabama,
1936

Gelatin silver print
18 x 22 cm
ML/F 1984/39

Gruber Donation

Evans, Walker

1903 St. Louis,
Missouri
1975 New Haven,
Connecticut

Walker Evans, who originally wanted to become a writer, discovered
his passion for photography at the end of the twenties. He began his
career as a photographer with picture series about Victorian architec-
ture in America and a reportage about the political unrest in Cuba in
1933. His early work already exhibited his objective, highly detail-con-
scious outlook, which was to earn him his fame as one of the most
talented documentary photographers of his time. He himself described
his photographs as "documentary in style", and he gave himself the
challenge of maintaining the purity of the art of photography. In October
1935, Evans joined the Farm Security Administration (FSA), which was
a federal authority during the Roosevelt era that developed aid pro-
grams for small farmers and tenant farmers during the years of the
Great Depression. In this project, photography was used as evidence,
documenting the abject poverty of the rural population for dissemina-
tion to a broader public – a project that combined political and socio-
critical, documentary and aesthetic interests in an unprecedented man-
ner. His efforts for the FSA became the most important segment of
Evans' work. Using the same objective precision with which he had
earlier photographed the architecture of his country, Evans was now

▶ **Walker Evans**
Louisiana, 1936

Gelatin silver print
24.2 x 18.9 cm
ML/F 1984/38

Gruber Donation

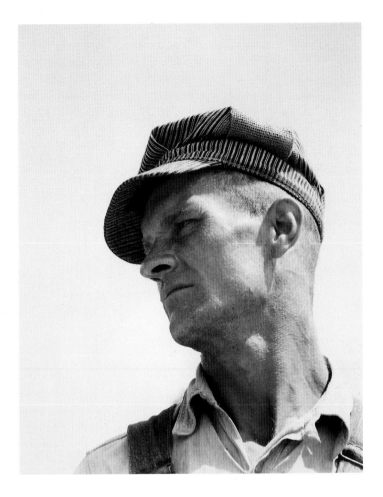

recording the life of the poor. It was during this period that he made the photograph of the skeptical but proud farm worker who appears in the picture entitled *Louisiana,* as well as the photograph of the two children dressed in meager rags who appear in the photograph entitled *Children in Alabama.*

In 1938, one year after Evans had finished his work for the FSA, the Museum of Modern Art in New York honored the achievement of this photographer with a solo exhibition, the very first that this museum dedicated to a photographer. *MBT*

Fehr, Gertrude

1895 Mainz
1996 Territet,
Switzerland

▶ **Gertrude Fehr**
Solarized Torso,
around 1935

Gelatin silver print
41 x 29 cm
ML/F 1987/158

▼ **Gertrude Fehr**
Odile, around 1940

Gelatin silver print
20.3 x 25.5 cm
ML/F 1987/159

Gertrude Fehr studied photography in the studio of Eduard Wasow and at the Bavarian State Educational Institute for Photography in Munich. She then operated a studio for theater and portrait photography in the Schwabing area of Munich until 1933. During the Third Reich era she moved to Paris, where she and her husband, the painter Jules Fehr, opened their own school of photography, which they called PUBLI-phot. Influenced by the Paris art scene, with which she maintained close contact, she began to experiment. She was particularly fascinated by the work of Man Ray, which motivated her to work with techniques like solarization, collages and abstractions. In doing so, she ventured into a type of work that is extremely unconventional for professional photographers. When the circumstances of war forced her to close the school, she clung to the idea of a photographic school, and immediately following her move to Switzerland, she founded a new school for photography, which she called "École Fehr".

In 1945, she turned the school over to the public domain represented by the Ecole des Arts et Métiers in Vevey, where she continued to teach for another 15 years. Gertrude Fehr radiated a great influence as a teacher. Among her pupils were such successful photographers as Monique Jacot, Yvan Dalain and Jeanloup Sieff. Since 1960, Gertrude Fehr has limited her work to freelance photography, devoting herself mostly to portrait-ure. In Germany, her work remained forgotten for a long time. Exhibitions in the City Museum of Munich and at the Museum Ludwig in Cologne brought it back to the attention of the German public. Gertrude Fehr remained active into her advanced age and even changed residence and studio once again at more than 90 years of age. She died in 1996 in Territet near Montreux, Switzerland. *RM*

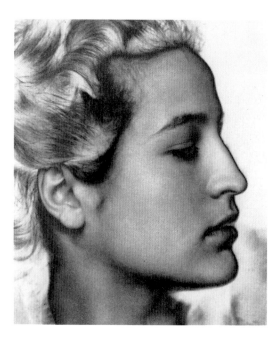

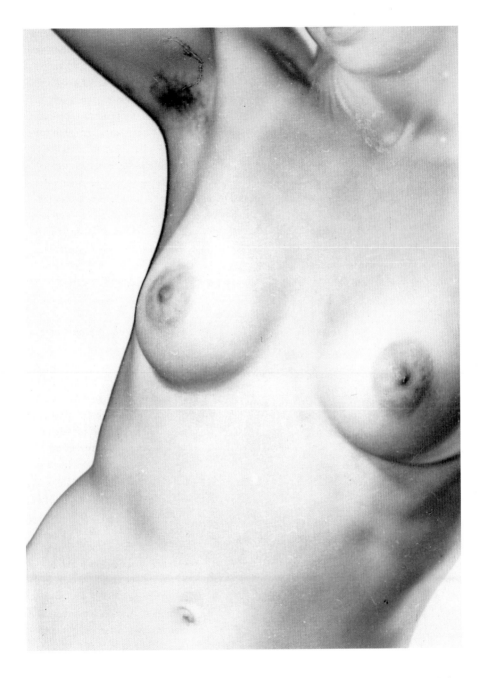

Andreas Feininger spent his youth in Germany, where he studied at the Bauhaus in Weimar and at the State School of Architecture in Zerbst. At first he worked as an architect in Dessau and in Hamburg, but towards the end of the twenties he began to be interested in photography. His first publications about photography appeared in 1930. In 1932 Feininger emigrated to Paris, where he initially worked for Le Corbusier. Later on he founded his own company for architectural and industrial photography in Stockholm. In 1939 he moved to New York and devoted himself entirely to photography. He worked for *Life* magazine and was considered to be one of the founders of contemporary photojournalism. After that period, he concentrated exclusively on the publication of his own books.

▼ Andreas Feininger
Detail of a Bivalve
Clam, around 1972

Gelatin silver print
34.5 x 27 cm
ML/F 1993/185

Gruber Donation

Feininger has a unique way of combining picture contents with formal criteria such as structures, picture composition and perspective. His photographs of New York are always structured architectonically, conforming to the rectangle of the picture, and never seeming like views

through a frame. The basic principle of his photographic work is especially evident in the example of picture composition, which he himself describes as "clarity, simplicity and structure". But he simultaneously demands that pictures must say something to the observer. To him, technical perfection is never an end in itself. Photographs like *New York, Cruiser United States* (1952) or *New York, Midtown Manhattan at 42nd Street* (1947) convey his architectonic outlook, the rigorous structure and the intensity of his pictures in a powerful way.

In his photojournalistic work for *Life* magazine, Feininger placed particular emphasis on a judicious combination of picture content and picture expression. According

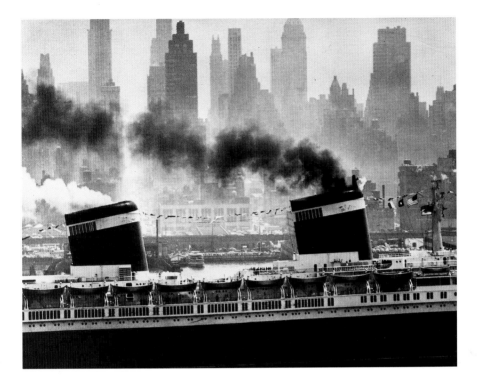

to Feininger, the story has to be told by the pictures themselves, so that the accompanying text can be reduced to a minimum. If the content is the prerequisite for a picture, then its organization and its composition determine its quality. Feininger himself observed this fundamental principle of journalistic work during his many years at *Life* magazine, thus helping to shape the image of this publication.

Feininger's photography covers the entire spectrum of photographic activity: from lively street scenes to carefully composed city views, from nearly abstract landscapes to minute details of plants, stones, shells or sculptures. He mastered the narrative as well as the strictly composed picture, and he accomplished the blending of both criteria in his photojournalistic reports. *RM*

▲ **Andreas Feininger**
New York, Cruiser
United States, 1952

Gelatin silver print
26.7 x 34.2 cm
ML/F 1993/192

Gruber Donation

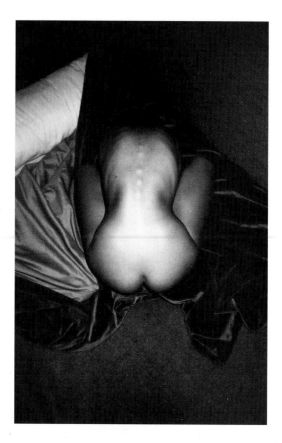

◄ **Franco Fontana**
Crouching Back
Nude, 1983

Color print
34 x 22.5 cm
ML/F 1993/205

Gruber Donation

▶ **Franco Fontana**
Nude, 1984

Color print
34 x 22.3 cm
ML/F 1988/99

Gruber Donation

Fontana, Franco

1933 Modena
Lives in Modena

In 1961, Franco Fontana devoted himself completely to photography. In 1964, the magazine *Popular Photography* published his first portfolio, and in 1970 he published his first book, *Modena una Città*. In the seventies his most important subjects were landscapes, which he reduced to abstract basic structures. The horizontal is usually the structural element which, in the form of a horizon, the border of a field, a street or a beach, subdivides the picture area. Restrained and rigorous as the composition was, it was invigorated by intensive, even luminous colours, a creative principle that he also applied to other subjects. In addition to his photographic activity, Fontana also made a name for himself as the organizer of the San Marino International Photomeeting. *RM*

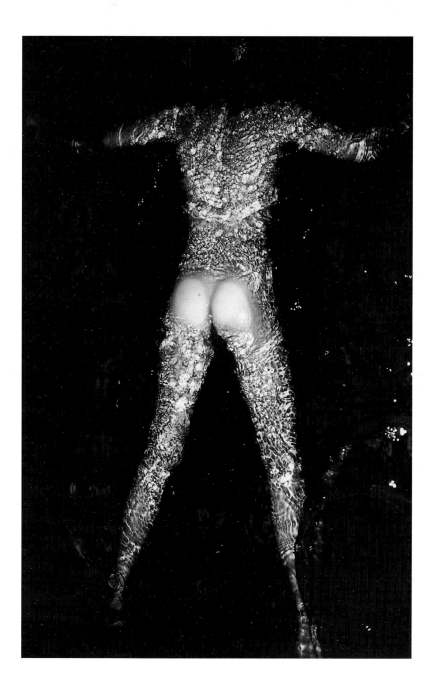

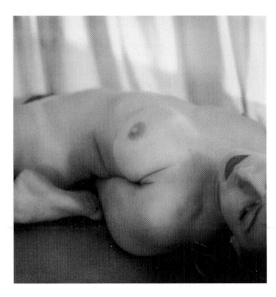

◄ Toto Frima
Untitled, 1985

SX 70 Polaroid print
8 x 8 cm
ML/F 1993/217

Gruber Donation

► Toto Frima
Untitled, 1988

Polaroid print
87.5 x 56 cm
ML/F 1995/125

Uwe Scheid
Donation

Frima, Toto

1953 The Hague
Lives in Amsterdam

After quitting her studies at an agricultural school, Toto Frima moved to Amsterdam. From 1970 to 1979 she lived there with a painter, for whom she also posed as a model. It was during this period that she created her first Polaroid images, which were to become her most important medium throughout her entire career. During the first years, she used a Polaroid SX 70 camera, with which she recorded her staged sets on the small square format. While doing that, she did not slip into other roles, but always remained herself. She demonstrates how this self changes and is finally converted into the woman herself by means of the multitude of views. This is magnified by her adopting the 50 x 50 cm Polaroid format, which requires more careful staging and more intense working, because the camera is not constantly and arbitrarily available. On the other hand, Toto Frima developed a type of multi-part work steps, in which framed photographic components are assembled into diptychs or triptychs, with the cut edges remaining visible. This reduction into individual elements reduces the tendency of de-individualizing the pictures within their assemblage. Toto uses herself to introduce us to woman as the universe. *RM*

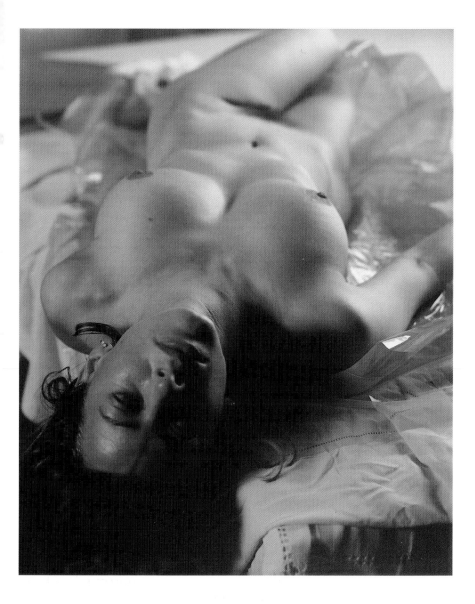

Gibson, Ralph

1939 Los Angeles
Lives in New York

▼ Ralph Gibson
From: The Somnam-
bulist, 1968

Gelatin silver print
31.4 x 20.8 cm
ML/F 1988/84

Gruber Donation

Ralph Gibson studied photography from 1956 to 1960, while he was still doing his military service in the US Navy. After his discharge, he attended the San Francisco Art Institute from 1960 to 1961. In 1962 he became an assistant to the famous social documentary photographer Dorothea Lange. In 1969 Gibson went to New York, where he became an assistant to Robert Frank, who was making the film "Me and My Brother". Still in that same year, he founded "Lustrum Press", a publishing house through which he published his own books as well as those of other photographers.

In his photographic work, Gibson first concentrated on black-and-white photography. He especially preferred grainy films in order to lend a more graphic effect to his photographs. For subjects, he had a preference for fantastic and surrealistic scenes, which he staged with fragments and excerpts from reality. He liked to use a wide-angle lens for deliberate spatial distortion in order to accentuate the dynamics and tension in his pictures. One of his most successful "Ghost" series was *The Somnambulist* of 1968, which included the picture of the silhouette of a hand in bright light coming through a partly opened door. According to L. Fritz Gruber, this photograph has become the photographer's "signature icon". *MBT*

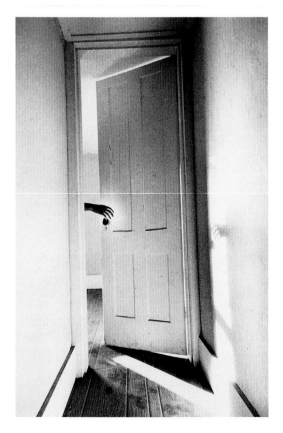

▶ Ralph Gibson
From: The Somnam-
bulist, 1968

Gelatin silver print
24 x 15.6 cm
ML/F 1993/226

Gruber Donation

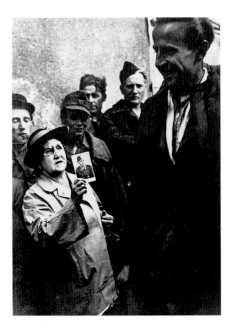

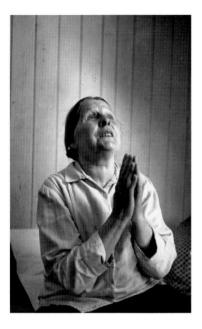
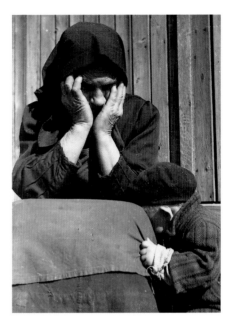

Ernst Haas discovered his passion for photography early on – in his own words, when he was still a child. His emotional photographs of the arrival of the first train with returning prisoners of war in 1950, when he was a freelance journalist for the magazines *Der Film* and *Heute*, earned him a lot of attention. Soon afterwards, he joined the "Magnum" agency. Beginning in 1951, Haas used primarily colour film as a freelance photographer for *Life, Look, Vogue*, and *Holiday*. This resulted in the reportage about New York entitled *Images of a Magic City* and the sports reportage *The Magic of Colour in Motion.* Haas began to distance himself more and more from sensationalistic photojournalism. In 1964 he produced "Days of Creation" for John Houston's film "The Bible". The corresponding book *Creation* was published in 1971. At this time the photographer began to experiment with audio-visual techniques. *Flower Show* and the portfolio *Flowers*, produced in 1983, demonstrate that details of flowers were important subjects in his late work. Shortly before his sudden death in 1986, Haas presented his audio-visual show *Abstracts. NZ*

Haas, Ernst

1921 Vienna
1986 New York

◄ ▲ **Ernst Haas**
Homecoming,
1947–1950

Gelatin silver print
ca. 18 x 12 cm
ML/F 1983/122, 123,
124 and
1993/245, 246, 249,
252, 253

Gruber Donation

Häusser, Robert

1924 Stuttgart
Lives in Mannheim

▼ Robert Häusser
The 21 Doors of
Benito Mussolini,
1983

*Gelatin silver print
each 39 x 28, (alto-
gether 140 x 200) cm*
ML/F 1986/93

Robert Häusser studied at the College for Graphic Design in Stuttgart
from 1941 to 1942. He was a soldier in 1944 and 1945. From 1946
to 1952 he lived as a farmer on his parents' farm in the Brandenburg
Marches, where he made his first portraits of farmers from the sur-
rounding area. In 1950 he began studying at the School of Applied Arts
in Weimar. In 1952 he moved to Mannheim, where he set up a studio
for photography. In 1969 he co-founded the Association of Freelance
Photodesigners (BFF). Häusser was also very active in cultural politics,
and he was a member of the German Association of Artists, the Mann-
heim Academy for the Creative Arts, the "Darmstadt Secession". In
the German Society of Photographers (GDL), he held the office of
vicepresident. As part of these functions, he initiated a programmatic
reorientation of this society, a self-critical examination of its role in
the Third Reich, and its reorganization as the German Photographic
Academy (DFA).

Häusser made his living from the publication of numerous pictorial
books on cities and landscapes, as well as from his work for artists. Yet
his main interest lay in his own artistic endeavours, which can be classi-
fied into various phases. During the first phase, his photographs were

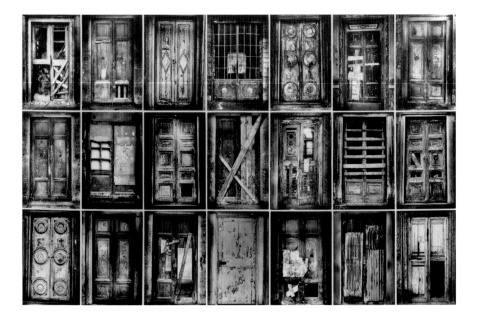

mostly narrative, but with a dramatic, heavy and sombre expression. From 1952 to 1954 he changed to a bright period, creating light and delicate photographs that often seemed more like drawings. As a result of his work on his parents' farm in Brandenburg, farm life continued to interest, as evinced in his series *Home Slaughtering*, a photographic essay in six pictures. Häusser became more and more interested in political subjects and in human fringe situations, like loneliness, bleakness, desperation and death.

His series *The 21 Doors of Benito Mussolini* is one of his principal works. The 21 doors represent the 21 years of the Mussolini government, and were all just as Häusser found them in the Duce's villa. The pictures are accompanied by the Mussolini statement: "When a man fails together with his system, then the case is irrevocable." *RM*

▲ **Robert Häusser**
In the Housemaid's Room, 1960

Gelatin silver print
48.8 x 59.3 cm
ML/F 1993/285

Gruber Donation

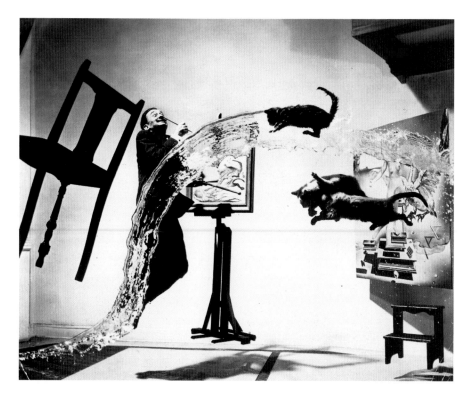

Halsman, Philippe

1906 Riga, Latvia
1979 New York

▲ Philippe Halsman
Dalí Atomicus, 1948

Gelatin silver print
26.6 x 33.3 cm
ML/F 1977/300

Gruber Collection

Philippe Halsman is one of the most original and inventive portrait photographers of our century. Before he turned to photography, Halsman studied electrical engineering in Dresden. It was only in 1928, when he went to Paris, that he established himself as an independent fashion and portrait photographer. In 1940 he emigrated to the USA, where he took on numerous assignments for *Life* magazine. In 1959 he published his successful series entitled *Jump Pictures,* which were photographs of prominent personalities performing jumps in front of his camera. This series is characteristic of the witty humor that permeated all his work. Equally characteristic is the surrealistic touch of his work, which can be ascribed to his friendship with Salvador Dalí. Halsman worked jointly with Dalí on various projects for more than 30 years, expressing the painter's ideas with the medium of photography. *MBT*

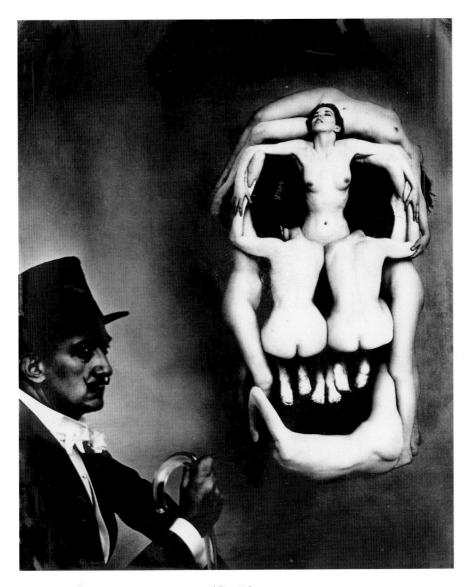

▲ **Philippe Halsman**
Dalí's Skull of
Nudes, around 1950

Gelatin silver print
10.8 x 8.8 cm
ML/F 1993/268

Gruber Donation

**Hamaya,
Hiroshi**

1915 Tokyo
1999 deceased

▼ Hiroshi Hamaya
A Rice-Planting
Woman, 1955

Gelatin silver print
29.7 x 19.9 cm
ML/F 1977/312

Gruber Collection

Hiroshi Hamaya started taking pictures at the age of 15. He founded a photographic club in 1933 and in the same year began working for the Oriental Photographic Manufacturing Company. In 1937 he established himself as an independent freelance photographer. Hamaya quickly became known and in 1940, like many of his colleagues, he went to Manchuria as a photographic war correspondent. Between 1945 and 1952 Hamaya lived in Takada, later moving to the town of Oiso near Tokyo. In 1960 he joined the "Magnum" agency. During the years that followed, Hamaya made many trips to America and Europe.

Hamaya documented the life of his countrymen in many photographic essays. One of the best known of these essays was his series about the Niigata region. Over a period of about 20 years, Hamaya repeatedly photographed the simple life in this countryside, which is covered with snow for three quarters of the year.

In addition to such photographic essays, Hamaya also made a name for himself with his aerial colour photographs of landscapes, which he made from an aircraft. Quite unlike Hamaya's photographic reportages, human beings no longer play any roles in his aerial views. The imposing formations of nature speak for themselves in these impressive documents of natural history. *MBT*

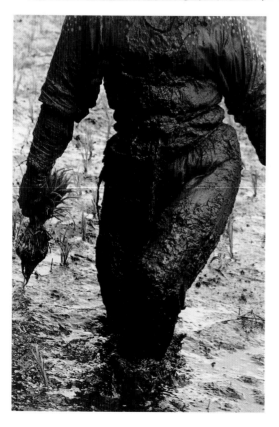

► Hiroshi Hamaya
Women Washing,
around 1955

Gelatin silver print
29.9 x 20 cm
ML/F 1977/323

Gruber Collection

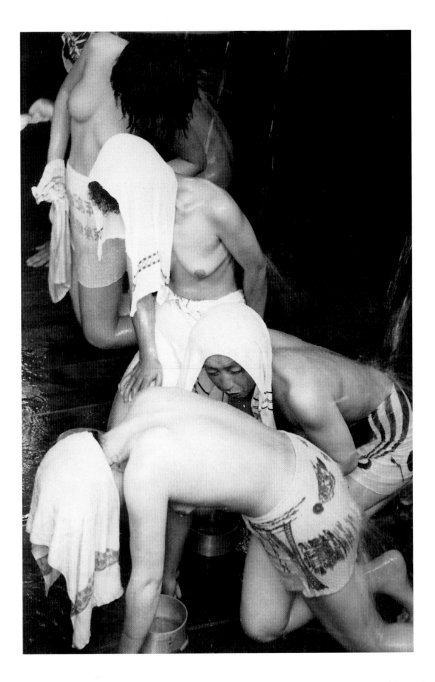

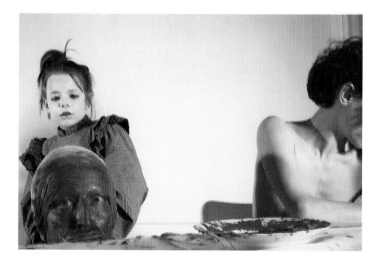

► **Gottfried Helnwein**
Arno Breker, 1988

Gelatin silver print
99.2 x 66.2 cm
ML/F 1992/85

Carola Peill
Donation

► ► **Gottfried Helnwein**
Andy Warhol, 1983

Gelatin silver print
99.2 x 66.2 cm
ML/F 1992/86

Carola Peill
Donation

Helnwein, Gottfried

1948 Vienna
Lives in Ireland

▲ **G. Helnwein**
The Last Supper, 1987

Color print
59 x 40 cm
ML/F 1987/154

► **G. Helnwein**
William S. Burroughs, 1990

Gelatin silver print
99.2 x 66.2 cm
ML/F 1992/83

Carola Peill Donation

► ► **G. Helnwein**
Michael Jackson, 1988

Gelatin silver print
99.2 x 66.2 cm
ML/F 1992/84

Carola Peill Donation

Gottfried Helnwein studied at the College for Graphic Design and Research in Vienna from 1965 to 1969. The first modest performances took place during this time. From 1969 to 1973 he studied painting at the Academy for the Creative Arts in Vienna, and concerned about everyday violence tolerated apathetically by the public, began a series of hyper-realistic paintings of injured children. In 1970 he and two fellow students staged a performance under the slogan *The Academy is on Fire*. In 1973 he created his first magazine cover for the publication *Profil*. In 1981 he began a series about trivial heroes of the present, and he also initiated a photographic working group whose work was later published under the name *Faces*. Helnwein worked with the media of painting and photography, created stage sets and performances, and campaigned for doing away with the separation of art into categories such as entertaining art and serious art. With this in mind, he published his work on posters and on the covers of large magazines. He also took his art to the streets, as he did in 1988 with *The Night of the Ninth of November* on the occasion of the "International Photo Scene Cologne" between the Museum Ludwig building and the main railway station in Cologne. Helnwein is regarded as one of the most important, politically committed artists in Germany, considering public reaction to be part of his artistic work in the sense of conceptual art. He is always seeking new ways to disseminate that work. *RM*

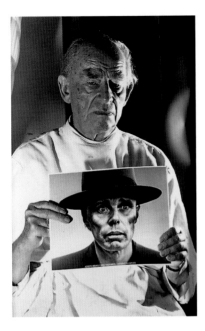

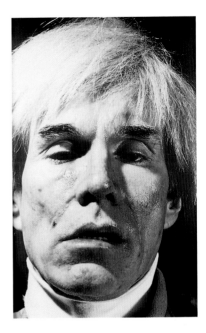

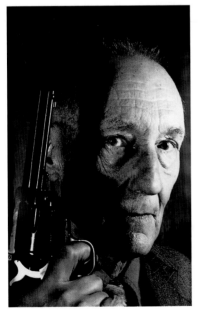

Henle, Fritz

1909 Dortmund
1993 Virgin Islands

▼ **Fritz Henle**
Grandma Moses,
around 1947

Gelatin silver print
31 x 27.4 cm
ML/F 1977/332

Gruber Collection

Fritz Henle turned to photography after a brief period as a physics student in Munich. The first publication of one of his photographs, a view of a blast furnace in his home town, took place when he was only 20. Hannah Seewald noticed his work and arranged for his admission to the Bavarian State College for Photography in Munich, where he completed his studies with an honors diploma. Soon afterwards he spent a year in Florence working on an assignment to photograph art treasures of the Renaissance.

The pictures he made of the Toscana during that same period attracted the attention of the steamship line "Lloyd Tourismus", for whom he travelled all over Italy during 1934. In the years 1935 and 1936 he was able to make photographs in China and in Japan. In 1936 he photographed on assignment for "Time-Life", and his pictures were published in *Fortune* magazine. His subsequent trip to America enabled him to establish connections with *Life* magazine, which facilitated his emigration to the USA. He became a US citizen in 1942. Henle photographed the USA as a freelance photojournalist working for a variety of magazines, such as *Fortune, Life*, and *Harper's Bazaar*. From the beginning, the Rolleiflex camera was his trademark and America his subject. He mastered the square format with great skill, combining in it both balance and tension.

In 1958 he gave up his studio in New York and settled in St. Croix on the Virgin Islands, where he married his favourite model. Henle, who always strove to emphasise the positive aspects of life and visualize them in his pictures, found pristine beauty on the islands, and he considered it his special duty to pass it on. He achieved outstanding fame as a nude photographer, especially in the fifties, and this was the subject of his book *Fritz Henle – Figure Studies*. But he also made portraits of great personalities

of our century, cultivating a special relationship with Diego Rivera and
Frida Kahlo. His uncomplicated philosophy of life enabled him to retain
his vitality and his energy into the last years of his life.

From St. Croix, Henle frequently visited Europe for extended peri-
ods, because he did not want to lose contact with his homeland, his
colleagues, and museums. In 1989 he managed to get his photographs
of Paris published, which were made during a short period in 1939. *RM*

▲ **Fritz Henle**
Nievis, one of Diego
Rivera's models,
1943

Gelatin silver print
23.2 x 22.5 cm
ML/F 1989/137

Henri, Florence

1893 New York
1982 Compiègne,
France

▼ Florence Henri
Günther and Carola
Peill, 1957

Gelatin silver print
17.3 x 16.7 cm
ML/F 1983/13

Carola Peill
Donation

Florence Henri became known in the twenties and thirties as a trend-setting photographer of the New Vision. Her first artistic endeavours were in the medium of painting. Florence Henri studied painting in Berlin and Munich, and in 1924 she went to Paris to attend the Académie André Lhotes and the Académie Moderne, which were directed by Fernand Léger and Amédée Ozenfant. In 1927 she successfully applied for the preparatory course at the Bauhaus in Dessau. There she was inspired in particular by László Moholy-Nagy, under whose influence she began to take an interest in photography. While her course was still in progress, she already began familiarizing herself with the creative possibilities of this medium, and under the guidance of her teacher experimented with unconventional perspectives, multiple exposures, montages, reversal of tonal values and the like.

Florence Henri returned to Paris in 1929. At this point, she had already earned broad recognition for her photographic work and was invited to participate in such important exhibitions as "Contemporary Photography" in Essen and "Film and Photo" in Stuttgart. Photography caused her painting to recede more and more into the background. In Paris Florence Henri began to specialize in portraiture. Her models were mostly celebrities from the artistic and intellectual circles of Paris. In addition, she also created a series of anonymous portraits, so-called

Portrait Compositions. Utilizing unusual perspectives and rigorous and intimate croppings in these pictures, the photographer overcame any distance she might have had towards portraiture.

Another important category in the work of Florence Henri consists of her *Compositions with Mirror.* In these dense arrangements of fruit, plates, reels of thread, perfume bottles or purely geometric objects that were thought out to the last detail, and by the use of one or more mirrors, she succeeded in upsetting the familiar central perspective

spatial arrangement of photography. With this fragmentation of picture planes, Florence Henri reverted to the cubist form elements of her early abstract paintings on one hand, and on the other she showed the definite influence of Constructivism in her clear, constructed still-life compositions with the resulting structuring line arrangements. In her 1957 portrait of Günther and Carola Peill, Florence Henri still made use of this style of visual expression of the twenties and thirties by positioning the couple behind the banister of a staircase. The rods of the banister thus became a constructivist structuring element of the picture's composition.

Florence Henri left Paris in 1963 to retire in the small village of Bellival in Picardy, where she gave up photography altogether and devoted herself entirely to her original vocation of abstract painting. *MTB*

▲ **Florence Henri**
Composition II, 1928

Gelatin silver print
17.2 x 23.9 cm
ML/F 1976/6 IV

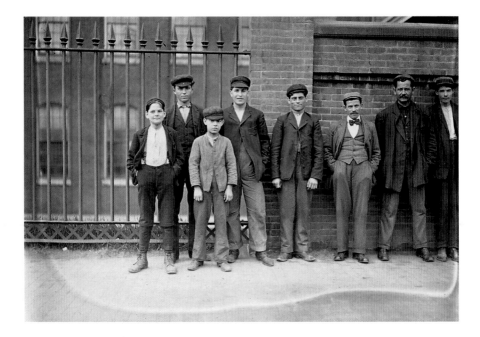

Hine, Lewis Wickes

1874 Oshkosh,
Wisconsin
1940 New York

▲ **Lewis W. Hine**
Untitled, around 1910

Gelatin silver print
11.8 x 16.9 cm
ML/F 1986/139

Jeane von Oppenheim
Donation

▶ **Lewis W. Hine**
Glass Factory, 1908

Gelatin silver print
16.7 x 11.8 cm
ML/F 1986/138

Jeane von Oppenheim
Donation

The former sociology and education student Lewis W. Hine was the outstanding exponent of social documentary photography in America. He started working for the National Child Labor Committee (NCLC) in 1906, and he continued working with that organization until approximately 1917. In 1908, under the auspices of the NCLC, he photographed children working in coal mines and factories. In 1909, the Child Welfare League used his photographs in its campaign against child labour. During further travels throughout the USA, Hine documented the social conditions of children, and he also gave lectures on behalf of the NCLC. In 1918 Hine joined the Red Cross, which dispatched him to France. From there he also travelled to Italy and to Greece, returning to New York in June 1919. There he changed his emphasis from an objective, clear documentation without emotion to a more interpretive style of photography. His advertising was now headlined "Lewis Wickes Hine, Interpretive Photography". In 1930, Hine was given the assignment of documenting the gigantic construction project of the Empire State Building. With his photographs of workers he sought to demonstrate that it was not the machine, but man who created affluence. *MBT*

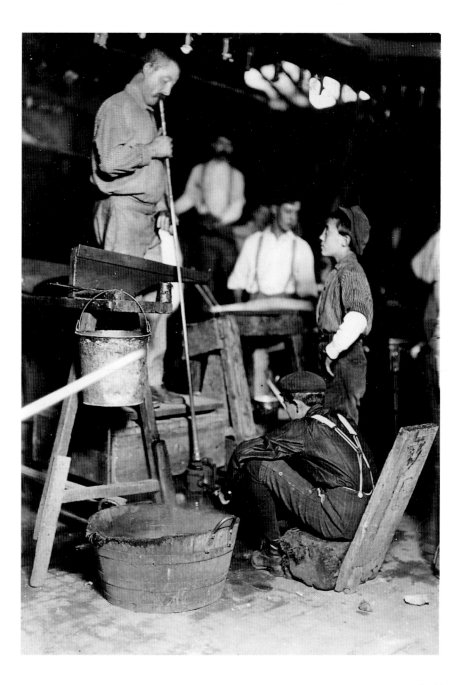

Hockney, David

1937 Bradford,
England
Lives in Los Angeles

David Hockney studied from 1953–1957 painting and drawing at Bradford College of Art and 1959–1962 at the Royal College of Art, London. In 1963 he moved to Los Angeles to take advantage of its more liberal political climate. His early work made an important contribution to British Pop Art, but in the USA Hockney took his own directions.

Los Angeles inspired him to his famous pool paintings. From 1968 David Hockney turned to photorealist painting and developed a subtle style of drawing. After a period involved with stage design (*The Rake's Progress*), in 1982 Hockney began working with Polaroids. Over the next two years he created the bulk of his in some cases large format Polaroids and photo-collages, although their subject matter and methods had already been staked out years before by his *Joiners*. These connections first became evident in the 1997 exhibition "David Hockney – Retrospektive Fotoworks" in the Museum Ludwig, Cologne. Subsequent to these photo works came his *Very New Paintings*, in which he explored the landscape, his Xerox pictures, which he also showed at exhibitions

in fax form, and his installation *The Snail's Space – Painting as Performance*. This work constitutes a résumé of the experiences he gained from landscape painting and theatre work, as shown in paintings, photography and drawing.

For the exhibition in Cologne he produced an installation involving large photographic collages based around the "Grand Canyon" and "Yorkshire" (*Husbandry in East Riding*), which the year after he rendered once more as painting collages. He is currently continuing his investigations into the relation between photography and painting with a study on the camera obscura. *RM*

▲ **David Hockney**
Husbandry in the
East Riding, 1997

Color Laser Print
218,4 x 819,2 cm
ML/F 2000/148

Hoepffner, Marta

1912 Pirmasens, Germany
2000 Kressbronn

▼ Marta Hoepffner
Firebird, 1940

Gelatin silver print
29.7 x 22.2 cm
ML/F 1989/82

In her youth, Marta Hoepffner was interested in the natural sciences. Her first artistic inspiration came from her relative Hugo Ball. After her parents moved to Frankfurt on Main in 1928, Marta Hoepffner earned her tuition money by doing office work. After one semester at the Arts and Crafts School in Offenbach, she began studying painting, graphic design and photography at the School for the Arts in Frankfurt on Main, where she derived a great deal of motivation from her teacher, Professor Willi Baumeister. This is also where she became aware of photography as an art form. When the Nazis discharged Baumeister, Marta Hoepffner left the art school and opened her own studio in 1934, where she conducted photographic experiments and created photographic montages and abstract photograms in addition to running her photographic business. After her studio was destroyed in wartime 1944, she moved to Hofheim in the Taunus Region. Here, she created her first interference pictures with polarized light. Many of her photographs were inspired by the composition principles of contemporary artists such as Giorgio Morandi and Wassily Kandinsky. In 1949 she was joined by her sister in founding the private Marta Hoepffner Photographic School. The curriculum, which also included theory, was based on the principles of the Bauhaus. The first colour photograms were created in 1956. In 1966 she developed her first "variochromatic light objects". In 1971 she moved to Kressbronn on Lake Constance and gradually turned her teaching activities over to her assistant Irm Schoffers. Since 1975 she has only been freelancing. *RM*

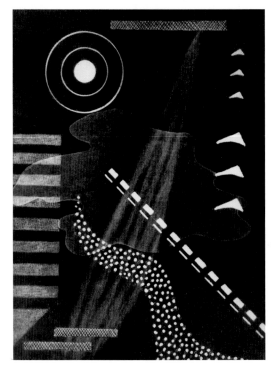

▲ **Marta Hoepffner**
Composition with
Bottles, 1945

Gelatin silver print
34.8 x 28 cm
ML/F 1989/79

Horst, Horst P.
(Paul Bohrmann)

1906 Weißenfels, Germany
1999 New York

▶ Horst P. Horst
Mainbouchet Corset, Paris, 1939

Gelatin silver print
24.2 x 19.2 cm
ML/F 1984/66

Gruber Donation

▼ Horst P. Horst
Coco Chanel, Paris, 1937

Gelatin silver print
20.6 x 19.7 cm
ML/F 1977/340

Gruber Collection

Horst P. Horst was attracted to photography through his friend George Hoyningen-Huene. Janet Flanner of the *New Yorker* discovered his pictures in a small exhibition in Paris-Passy. This led to his first job at *Vogue*, the magazine to which Horst was to remain loyal as a fashion photographer for the rest of his life. Horst may not have revolutionized fashion photography, but he certainly perfected it. The second generation in fashion photography still had to define fundamental concepts for the photographic approach to fashion. How representative or realistic should a fashion photograph be, how much should the respective fashion design be the centre of photographic interest, and how much could the photographer's creative concept prevail over these precepts? Horst had undertaken intensive studies of classical poses, he studied Greek sculpture and classical painting, and he devoted particularly meticulous attention to details such as the positioning of hands, because he was aware of the fact that most people did not know what to do with their arms and hands during photography. The combination of judicious poses and bearings, sparse accessories and simple but skilful lighting is typical of what is often described as Horst's illusionist talent. He magically transformed simple boards of wood into exquisite furniture. cardboard rolls into antique columns and plaster figures into marble sculp-

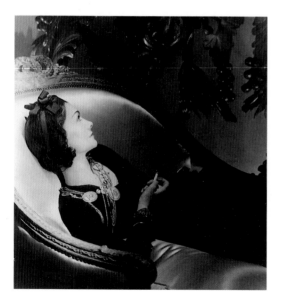

tures. He leaves, however, the ideal world that he creates as fiction, as the projection of an ideal conception of beauty. His beauty is distant, cool and unapproachable, erotic and seductive, but only as a figment of the mind. This distance between his photographs and reality makes him an artist of his time, who, even though he loves the material world, the illusions of advertising, of beauty and of fashion, and photographs it with devotion, is aware of its illusory character and for that very reason reveres it.
RM

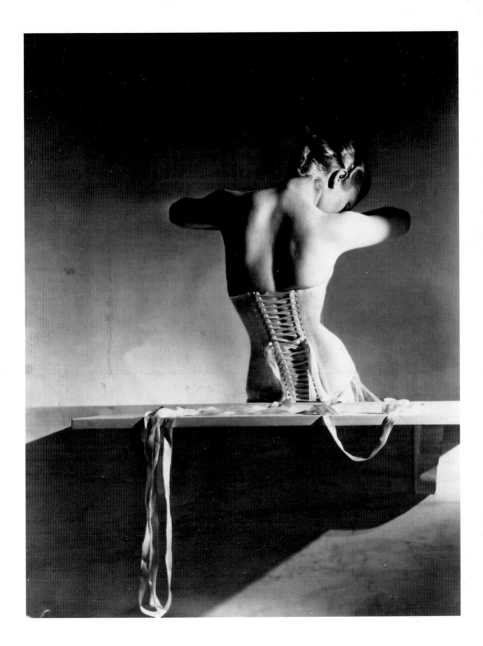

Horvat, Frank

1928 Abbazia, Italy
Lives in Paris

▶ Frank Horvat
In the Dressing
Room, 1963

Gelatin silver print
39 x 26 cm
ML/F 1977/346

Gruber Collection

▼ Frank Horvat
Fellini and a Model,
1963

Gelatin silver print
39.9 x 27.1 cm
ML/F 1977/345

Gruber Collection

Frank Horvat, whose father was a physician, fled to Lugano in 1939 and attended high school there. In 1944 he sold his stamp collection in order to buy a used camera. After returning to Italy, he studied drawing at the Accademia di Brera in Milan. In 1951 he submitted his first photographic essay about southern Italy, which was published by the magazine *Epoca*. His very first colour photograph was on the cover. That year he travelled to Paris for the first time, where he met Robert Capa and Henri Cartier-Bresson. In 1952 he travelled to India at his own expense. The photographs that he made there were published by *Paris Match*, *Picture Post* and *Life* magazine. In 1955, Edward Steichen selected some of his pictures for the legendary exhibition "The Family of Man". In 1958 Frank Horvat began working for *Jardin des Modes*, *Elle* and *Vogue*. He became a member of the "Magnum" agency in 1959, but remained there for only three years. In 1964 he started working for *Harper's Bazaar*, *twen* and *Elle*. During those years, he began to concentrate more and more on fashion photography.

Horvat is a highly versatile photographer who masters the most varied subjects, ranging from landscape and fashion photography to portraits. He is also very interested in experimentation. He began to stage his settings in the style of old masters, and more recently he has been using computers for picture montages in the Surrealist tradition. *RM*

▶ **George
Hoyningen-Huene**
Bathing Suits by
Izod, 1930

*Gelatin silver print
28.8 x 22.6 cm*
ML/F 1992/207

R. Wick Donation

▼ **George
Hoyningen-Huene**
Greta Garbo, 1951

*Gelatin silver print
34.2 x 26.6 cm*
ML/F 1977/349

Gruber Collection

George Hoyningen-Huene is considered to be one of the great exponents of fashion photography of the twenties and thirties. His career began after he moved to Paris in 1920, where he took up a great variety of jobs. He worked as a movie extra and studied painting. It was during this period that he also developed close contacts with the Paris art scene, befriending such legendary figures as Kiki de Montparnasse and Jean Renoir. He soon made a name for himself as a talented fashion drafts-man, and his work was published in *Harper's Bazaar* and *Fairchild's Magazine*. In 1925 he was hired by *Vogue*. It was approximately at that time that he began to turn more and more to photography, starting to work as an assistant to the American photographer Arthur O'Neill. A year later Hoyningen-Huene made his first fashion photographs for *Vogue* and thus gained entry into this field, in which he was particularly active in the years from 1926 to 1945. Many of his photographs from this period reflect his fascination with Surrealism and his interest in Greek antiquity. Flawless compositions with well-balanced lighting are as much a trademark of this photographer as are the inclusion of classical Greek props and surrealistic effects. In 1935 Hoyningen-Huene moved to New York, and in 1936 he began working almost ex-clusively for *Harper's Bazaar*. In 1943 he published his picture books *Hellas* and *Egypt*. In 1946 he went to Hollywood, where he became a sought-after portrait photographer of American movie stars, and where he also became active in motion pictures, espe-cially short features. *MBT*

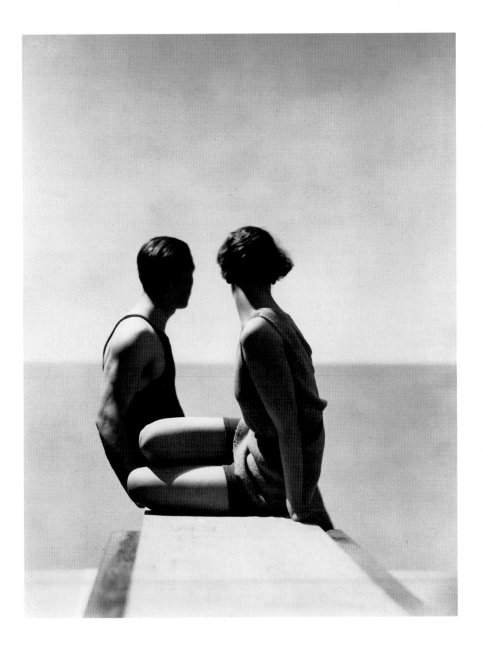

Huth, Walde

1923 Stuttgart
Lives in Cologne

▼ **Walde Huth**
Ambre, from:
Fashion of the
Times, 1962

Gelatin silver print
51.7 x 50.5 cm
ML/F 1989/107

Walde Huth originally wanted to become an actress or a mime, or painter and sculptor, but she acceded to her father's wishes for her to first study photography under Professor Walter Hege at the State School for Applied Art and Craft in Weimar. There she experienced light as a formative, creative medium and began to enthuse about photography. After completing her studies she started working in the colour film processing division of Agfa in Wolfen. In 1945–1949 she earned a living for herself and her parents as a self-employed photographer, doing portrait photography and with photographic assignments. In 1949 she turned to fashion photography and advertising, and in 1953 she opened a studio in Stuttgart. Her work for the *Frankfurter Illustrierte* provided her with an entry into *haute couture* photography in Paris and Florence. This resulted in an exclusive contract with the *Frankfurter Allgemeine Zeitung*. Walde Huth's open-air fashion work and her talent for bringing fashion and architecture into an expressive relationship found great acceptance, and in 1955 she turned down a contract with *Vogue*. After marrying Cologne architectural photographer Karl Hugo Schmölz in 1956, they worked in their jointly built studio block (from 1958 onwards) producing fashion, advertising, architectural and furniture photography.

After Karl Hugo Schmölz passed away in 1986, she gave up his additional large studio and concentrated entirely on making photographs according to her own conceptions. Her photographic cycles *100 Unwritten Letters. Photographic Modulations, 100 frozen Steps. Photographic Sequences, Eyed Existence, Aphrodite, Became a Figure* or *Optical Delicacies* exemplify her very individual approach to staged photography, to photographic found objects, and to serial photography. *RM*

▲ **Walde Huth**
Patricia, Evening
Robe by Jacques
Fath, Paris 1953

Gelatin silver print
57.4 x 49.7 cm
ML/F 1989/110

Ignatovich, Boris

1899 Lutzk, Ukraine
1976 Moscow

▲ Boris Ignatovich
Hermitage, 1929

Gelatin silver print
36.7 x 45 cm
ML/F 1992/131

Ludwig Collection

Boris Ignatovich achieved his first success with a photographic essay on rural subjects. In the late twenties, he had close contacts with Alexander Rodchenko, with whom he founded the photography section of the "October Group" in 1930. The friendly relationship with Rodchenko influenced Ignatovich's photographic style. He enjoyed taking pictures from extremely low or high camera positions, and discovered a new way of looking at everyday life. A sightseeing flight over Leningrad presented him with new possibilities for unconventional perspectives. He created bird's-eye views such as *Smokestacks and Factories of a Leningrad Industrial Complex,* in which architecture is rendered as an abstract-constructivist composition. After the war he devoted himself especially to landscape and portrait photography, and the possibilities of colour photography. *MBT*

▲ **Boris Ignatovich**
Isaac Cathedral,
1930

Gelatin silver print
19 x 24 cm
ML/F 1992/124

Ludwig Collection

◄ **Boris Ignatovich**
Smokestacks and
Factories of a
Leningrad Industrial
Complex, 1931

Gelatin silver print
13 x 18 cm
ML/F 1992/125

Ludwig Collection

◄ **Yousuf Karsh**
Jawaharlal Nehru,
around 1949

Gelatin silver print
31.3 x 25.3 cm
ML/F 1977/376

Gruber Collection

Karsh, Yousuf

1908 Mardin,
Armenia
Lives in Ottawa,
Canada

"The never-ending fascination for the people I photograph rests in
what I call their internal strength. It is part of the hard-to-define secret
hidden within everyone, and the attempt to capture this on film has
been my life's work." This is how portrait photographer Yousuf Karsh
has described the attraction of his work. In 1924, Karsh emigrated to
Canada, where his uncle, the established photographer George Nakash,
taught him the basics of the art. In 1928 he secured an apprenticeship
for his nephew with Boston portrait photographer John H. Garo. In
1932 Karsh opened his own portrait studio in Ottawa. He soon acquired
a reputation as an exceptionally talented portrait photographer, whose
clientele included high-ranking VIPs. In 1941 Karsh achieved his inter-
national breakthrough with his famous portrait of Winston Churchill,
which appeared on the title page of *Life* magazine and remains one of
the most reproduced portraits ever. In his work Karsh did not restrict
himself to his studio. He preferred to take portraits of his sitters in
their own familiar environment. *MBT*

▲ **Yousuf Karsh**
Winston Churchill,
1941

Gelatin silver print
31 x 25.3 cm
ML/F 1977/369

Gruber Collection

◀ **Peter Keetman**
Reflecting Drops,
1950

Gelatin silver print
23.2 x 30.3 cm
ML/F 1989/46

▶ **Peter Keetman**
Thousand and One
Faces, 1957

Gelatin silver print
30.3 x 23.3 cm
ML/F 1989/48

Keetman, Peter

1916 Wuppertal-
Elberfeld, Germany
Lives in
Marquartstein

Peter Keetman received his first photographic inspirations from his
father, who was a serious amateur photographer. At the age of 19 he
attended the Bavarian State Educational Institute for Photography in
Munich, where he obtained his apprentice's diploma in 1937. After
two years at the studio of Gertrud Hesse in Duisburg he worked as an
industrial photographer for the C. H. Schmeck Company in Aachen. In
1944 he returned from military service seriously wounded and unable
to work. Nevertheless he continued his studies at the aforementioned
Institute in the master's program and then studied under Adolf Lazi in
Stuttgart. Following his legendary exhibition in Neustadt/Hard in 1949,
Keetman was one of the founding members of the "fotoform" group.
Together with the other members of this group (Toni Schneiders, Wolf-
gang Reisewitz, Ludwig Windstoßer, Siegfried Lauterwasser and Heinz
Hajek-Halke) he showed his first pictures at Photokina in 1950. Keet-
man became known internationally through his experimental work, in
particular *Reflecting Drops. RM*

Kertész, André

1894 Budapest
1985 New York

▼ André Kertész
Esztergom, Hungary,
Swimmer, 1917

Gelatin silver print
19 x 24.7 cm
ML/F 1977/394

Gruber Collection

As a young man André Kertész found a photographic manual in an attic and decided to become a photographer. After the death of his father, however, he first attended the Academy of Commerce, and like his foster father, worked in the Budapest stock market. In 1913 he acquired his first camera, an Ica. In 1914 he served in the Austro-Hungarian army. One year later he began to work seriously as a photographer. He was wounded and for a year was paralyzed. All of his negatives were destroyed in 1918 and he returned to the stock market. In 1922 he received an honorary diploma from the Hungarian Association of Photography. Between 1922 and 1925 he lived in Paris, where he sold prints for 25 francs in order to make a living. During this time he began his collabouration with the *Frankfurter Illustrierte*, the *Berliner Illustrirte*, the *Nationale de Fiorenza, Sourire, Uhu*, and *Times*. In Paris he began his series *Distortions*. In 1927 he had his first solo exhibition and in 1928 met Brassaï, whom he introduced to photography. Kertész acquired his first Lei-ca and did documentaries for *Vu*. In 1933 he married Elisabeth Sali and published his first book on children. Three years later he emigrated to New York and signed a contract with Keystone. In 1937 he

▲ André Kertész
The Fork, 1928

Gelatin silver print
19.4 x 24 cm
ML/F 1977/381

Gruber Collection

began his association with *Vogue, Harper's Bazaar, Collier's, Coronet,* and many other magazines. In 1944 he became an American citizen. He attempted to bring over his negatives from Paris, but more than half were lost in transit. From 1949 to 1962 he worked continuously for Condé Nast.

After a serious disease, Kertész decided to cancel all his contracts and work exclusively as a freelance photographer. In addition to many honours, he received an honorary doctorate from the Royal College of Art and he was also made a member of the French Legion of Honor. Many of Kertész's photographs, for example *The Fork, Esztergom, Swimmer,* the *Park Bench,* or *Mondrian's Atelier,* are now among the most famous photographs of this century. *RM*

Klauke, Jürgen

1943 Kliding
Lives in Cologne

Jürgen Klauke studied at the College of Art and Design in Cologne and at first worked mainly in the field of drawing. In 1970 he began working with photography, using himself as a model. In 1971, in his book *I and I, Day Drawings and Photographic Sequences*, he provided an insight into his work hitherto. He considered provocation to be an important tool for compelling the consumer of art to contemplate. In his earlier self-portraits he presented himself decorated with the accessories of a society hungry for sex yet incapable of love. Remarkably early on he used himself as an object of the androgynous, a topic which is currently ubiquitously dominant in society, the arts and media. He realized many of his topics in the form of videos, but the photographic sequence remained his central medium. From the very beginning, his sequences dealt with questions of sexuality, the psyche, identity relative to the body and its marketing, seeing his own body only as a stand-in and as an example. Even political behaviour, belief in authority and obedience play a part in some of his sequences. Of essence, however, is also the humour which has been added to serious subjects and which ultimately suggests despair, as if laughter were the only way to deal with one's inability to effect change.

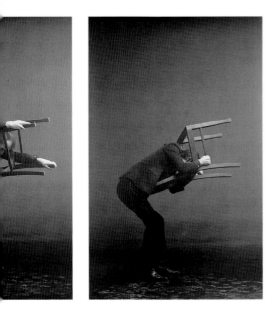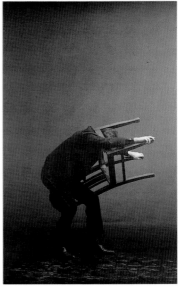

His cycle *Formalizing Boredom,* created between 1979 and 1980, was Klauke's breakthrough to international fame. He developed a pictorial language of stricter, yet less transparent rules of behaviour that were characterized by isolation and by an inability to communicate, but which were followed by the protagonists who appeared in the pictures. This was the first time he laid out his cycles in the form of multi-part, tabular displays, which added a meditative and simultaneously prosaic tone. In Klauke's art there is an exceptional congruence between work and person or art and life, which other artists often labour strenuously to achieve. With him this is a matter of course and effortless. Klauke His presence at his performance art has a persuasive effect, because his art and its message are obviously important to him. By linking a skeletal reduction of forms to monumental size, it is not only the self-portrait that allows an association with relics. *RM*

▲ **Jürgen Klauke**
Formalizing Bore-
dom, 1979–80

Gelatin silver print
each 180 x 110 cm
ML/F 1985/40 I-V

Klein, William

1928 New York
Lives in Paris

▲ William Klein
Rome, Guard at
Cinecittà, 1959

Gelatin silver print
27.4 x 30.4 cm
ML/F 1977/418

Gruber Collection

William Klein worked from 1954–1966 as a fashion photographer for *Vogue*, but did not wish to continue creating chic fashion poses, but instead at last to take "real pictures, eliminating taboos and clichés". Klein worked with unconventional wide-angle and telephoto pictures, with unconventional lighting and flash effects and with intentional motion blurs. Klein saw his real calling as what he calls "serious photographs". By that he meant uncompromising, unadorned documentaries about large cities like New York, Rome, Moscow, and Tokyo. Books about these cities enabled him to enjoy great successes. Around 1961 Klein gave up still photography – with the exception of a few jobs for newspapers and advertising – in favour of motion pictures. His politically committed and unconventionally produced motion-picture contributions put him in the position of a maverick. Only at the beginning of the eighties did Klein start to take still pictures again. At this time his earlier shots were rediscovered and given recognition. *MBT*

► **William Klein**
Playing Children
with Gun, 1954/55

Gelatin silver print
23 x 30.4 cm
ML/F 1977/419

Gruber Collection

◄ **William Klein**
Tokyo, 1961

Gelatin silver print
24 x 29.8 cm
ML/F 1977/411

Gruber Collection

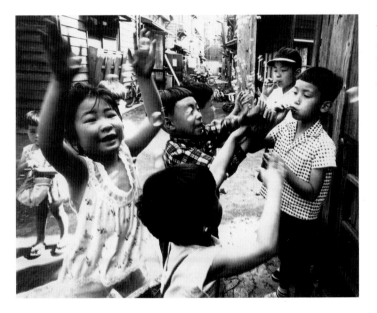

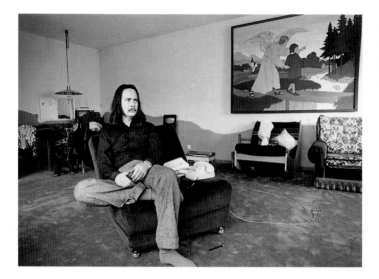

◄ **Barbara Klemm**
Peter Handke, 1973

Gelatin silver print
28.5 x 39.5 cm
ML/F 1984/146

Gruber Donation

Klemm, Barbara

1939 Münster
Lives in Frankfurt
on Main

Photojournalist Barbara Klemm received her training in a photographic studio in Karlsruhe. At the beginning of 1959 she found employment with the *Frankfurter Allgemeine Zeitung* (FAZ), starting as an engraver. Since 1970 she has been a photographer on the editorial staff, concerned mainly with the features section and politics. In this capacity Barbara Klemm documents daily events in the fields of economics, politics, and culture. Her works are usually titled only with location and year, a sign of her attitude of being an observer who participates, but who does not take a superior stand by means of an unusual perspective. Barbara Klemm's individual shots depict events of historical value and political arenas which, despite their modesty, illustrate characteristic moods of the moment. Her work, including the travel supplement of the *FAZ* keeps this journalist frequently on the move. The collection includes the photograph *Leonid Breschnev with Willy Brandt* from 1973. The people she photographs act unobserved, the camera appears not to exist. Still, the situations captured by Barbara Klemm are distinguished by their surprising perspectives and moments. Her method of cropping gives a feeling of balance based on aspects of form and composition, irrespective of the spontaneity of the moment when the picture was taken. In the eighties, Barbara Klemm's portraits of artists revealed another dimension of her work. Her photographs of her father,

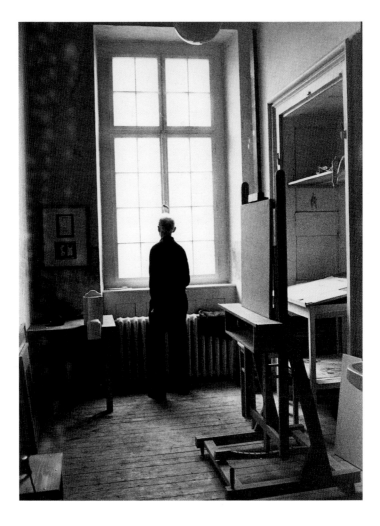

▶ Barbara Klemm
Fritz Klemm, 1968

Gelatin silver print
39.3 x 29.1 cm
ML/F 1984/147

Gruber Donation

the painter Fritz Klemm, in 1968, of George Segal in 1971, and of Peter
Handke in 1973 place her subjects in their environment from a distance,
conveying an impression of their work and attitudes. *LH*

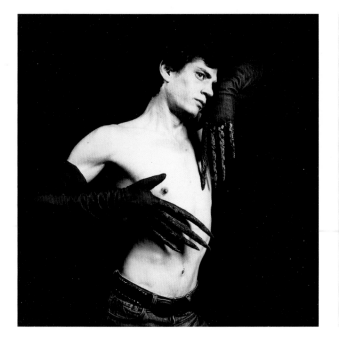

Koelbl, Herlinde

1939 Lindau
Lives in Munich

Herlinde Koelbl is a self-taught photographer who began taking pictures in 1975. She has worked for magazines such as *Stern, Zeit Magazin, New York Times,* and other illustrated magazines. As a photojournalist she travelled to many countries and on one such occasion produced a documentary on the Intifada that included pictures reminiscent of Biblical scenes. Her artistic work has always focused on publications. The subjects she chose were always treated with a view to publication. Her very first book *The German Living Room* created a sensation in 1980. Without disclosing their full names, she took pictures of well known as well as unknown people in their homes providing a surprising look into their "expanded self". In her publication *Fine People* she removed the mask of High Society after attending receptions, parties, gallery openings, and fashion shows with her camera and by observing not the activities themselves, but the people, their clothes and their behaviour. One of her first picture cycles called *Men* caused a furor because it depicted male nudes photographed by a woman. They showed clearly that a woman photographs men in a different manner than a man. This

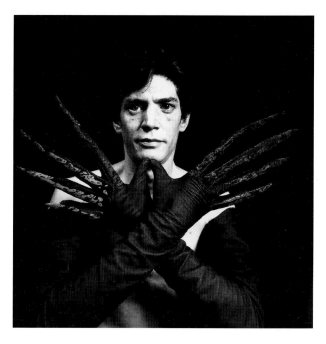

does not involve concentrating only on the gender. There are photographs of intellectuals with bodies untouched by body building, or tender photographs of old men. One of her most comprehensive and labour-intensive projects was *Jewish Portraits*. Herlinde Koelbl did not restrict herself to finding Jewish personalities of German intellectual history all over the world in order to make portraits of them. She created her portraits based on an intense dialog, which required that she prepare herself thoroughly with the substantial works of her subjects. As a result, *Jewish Portraits* became an overview of still living German-speaking Jewish intellectual greats and also an intelligent introduction to their work as provided by the records of the conversations. *RM*

▲ **Herlinde Koelbl**
Robert Mapplethorpe, 1983

Gelatin silver print
22.7 x 22.6 cm
ML/F 1985/101, 102, 103

Gruber Donation

Lange,
Dorothea

1895 Hoboken,
New Jersey
1965 San Francisco

▲ **Dorothea Lange**
Field Worker,
Texas, 1936

Gelatin silver print
24.5 x 32.5 cm
ML/F 1977/440

Gruber Collection

Dorothea Lange's oeuvre constitutes one of the most moving and committed contributions to the social documentary photography in the 20th century. After studying at Columbia University in New York she started out as an independent portrait photographer in San Francisco. Shocked by the number of homeless people in search of work during the Great Depression, she decided to take pictures of people in the street to draw attention to their plight. In 1935 she joined the Farm Security Administration (FSA) and reported on living conditions in the rural areas of the USA. In an unflinchingly direct manner she documented the bitter poverty of migrant workers and their families. One of the most famous photographs of the FSA project is *Migrant Mother*, the portrait of a Californian migrant worker with her three children. This highly concentrated image has made Dorothea Lange an icon of socially committed photography. *MBT*

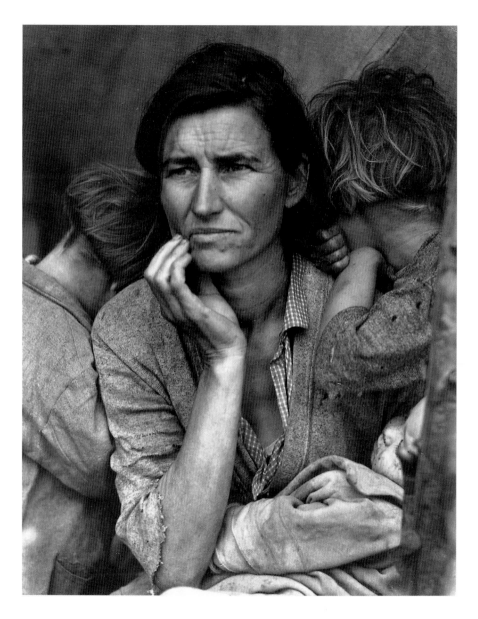

▲ **Dorothea Lange**
Migrant Mother, California, 1936

Gelatin silver print, 32.8 x 26.1 cm
ML/F 1977/442

Gruber Collection

Lartigue,
Jacques-Henri

1894 Courbevoie,
France
1986 Nice

▲ Jacques-Henri
Lartigue
Delaye Grand Prix,
1912

Gelatin silver print
20.8 x 28.7 cm
ML/F 1977/431

Gruber Collection

At the age of only six Jacques-Henri Lartigue was introduced to photog-
raphy by his father, a passionate amateur photographer. Two years later
he received his first camera as a gift. From then on he recorded all the
remarkable activities and hobbies of the well-to-do Lartigue family, such
as kite-flying, racing with automobiles, home-made motorcycles and
steerable bobsleds. He was particularly fascinated by the possibility of
freezing motion in a picture. Another subject he pursued with passion
was airplanes. Between 1908 and 1910 he created a collection of shots
of all types of airplanes and numerous pioneers of aviation. When the
family moved to Pairs in 1911, Lartigue discovered the eccentric world
of fashion in the Bois de Boulogne. In 1915 Lartigue decided to become
a painter, which was not, however, a detriment to his enthusiasm for
photography. More and more he developed into a chronicler of society
and cultural life, which he captured beginning with the Belle Époque,
through Art Déco and into the eighties. In 1963 Lartigue's work was
honoured with a large solo exhibition in the Museum of Modern Art
in New York. *MBT*

▲ **Jacques-Henri Lartigue**
Bois de Boulogne, 1911

Gelatin silver print
21.1 x 29.2 cm
ML/F 1977/430

Gruber Collection

◄ **Jacques-Henri Lartigue**
Auteuil, 1912

Gelatin silver print
22.2 x 29.1 cm
ML/F 1977/433

Gruber Collection

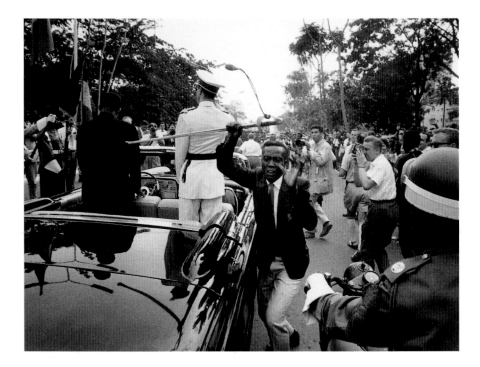

Lebeck, Robert

1929 Berlin
Lives in Port de
Richard, France

▲ Robert Lebeck
The Stolen Sabre,
Leopoldville, 1960

Gelatin silver print
50.7 x 60.7 cm
ML/F 1991/256

Robert Lebeck studied political science in Zurich and in New York. His 23rd birthday was a turning point in his life. On that day his wife presented him with a Retina 1A camera. On July 15, 1952, Lebeck had his first photograph published in the *Heidelberger Tagesblatt*. His first great success came in 1955 – the publication of a report in *Revue* magazine. The same year he was appointed director of the Frankfurt office of *Revue*. His breakthrough came in 1960, in Africa, with his work for *Kristall* magazine. In 1966 Lebeck joined *Stern*.

His earlier photographic documentaries in black and white and his later ones in colour were produced by this self-taught photographer with a minimum of technology. Pictures like *The Stolen Sabre* or went around the world. Lebeck's photography characterized the style of *Stern* photojournalism in a lasting manner. *NZ*

▲ **Robert Lebeck**
Jayne Mansfield, Berlin, 1961

Gelatin silver print, 61.4 x 50.7 cm
ML/F 1991/257

Lissitzky, El

1890 Portchinok,
near Smolensk
1941 Moscow

▲ El Lissitzky
Composition with
Spoon, around 1924

Gelatin silver print
23.4 x 29 cm
ML/F 1979/1404

Ludwig Collection

As early as the twenties El Lissitzky was one of the outstanding artists of the Russian avant-garde. Trained as an architect, he made a name for himself in painting, typography, and photography as an innovative intellectual, contributing significantly to the implementation and dissemination of constructivist and suprematist ideas. He became famous for his *Proun* work. *Proun* was a "project to affirm the new", with which Lissitzky envisioned the utopia of constructing a new space which was also intended to be the symbolic image of a new societal order to be established.

Lissitzky experimented in the field of photography from the early twenties and he was mainly interested in photomontages and photograms. He arranged preferably everyday objects such as spoons, pliers, glasses, and lace doilies on photographic paper, but unlike László Moholy-Nagy, he did not attempt to create an immaterial light space. In an article published in 1929 he summarized his ideas on photogram

methodology, in which he acknowledged the greater expressive force of photographic images: "The language of photography is not the language of the painter, and the photograph has properties which are not accessible to painters. These properties are intrinsic in the photographic material itself and must be developed if photography is to be turned into art, into a photogram."

Lissitzky utilized photograms and montages to design advertisements and posters. One of his most monumental projects in the area of photomontage was the photographic frieze he assembled of newspaper clippings and photographs for the Soviet pavilion at the international press exhibition "Pressa" in Cologne (1928). *MBT*

▲ **El Lissitzky**
Composition with
Pliers, around 1924

Gelatin silver print
23.4 x 29.1 cm
ML/F 1979/1405

Ludwig Collection

List, Herbert

1903 Hamburg
1975 Munich

▼ **Herbert List**
Covered Monument,
Athens, 1937

Gelatin silver print
30.7 x 23.8 cm
ML/F 1977/972

Gruber Donation

Herbert List entered photographic history as a master of the "fotografia metafisica". He started out with an apprenticeship in business and, between 1926 and 1928, travelled to South American coffee plantations, before returning to work as an attorney and partner in his father's business in Hamburg. At the end of the twenties he discovered his passion for photography. His friend Andreas Feininger, who had just completed his architectural studies at the Bauhaus, introduced him to the technical fundamentals of his field. Fascinated by the paintings of the Surrealists, List placed objects in alien, unfamiliar contexts or staged encounters between uprooted fragments of reality and attempted "to capture the magic of appearance in the picture". In 1936 political circumstances forced List to leave Germany, his home. Without means he went to London and made his hobby his profession. Already by the end of the thirties he could record a breakthrough as a successful photographer. In 1937 List and photographer George Hoyningen-Huene travelled to Greece. On Lycabettos' hill in Athens he shot a series on the topic of covering and uncovering. An individual covered in a white robe posed in the habit of theatrical stage appearances in the landscape and played with the ambiguity of front and back, male and female.

After the War List returned to Germany and settled in Munich, using it as a base for many trips in the years that followed. In 1962 he gave up photography and devoted himself to the collection and identification of Italian drawings. *MBT*

▲ **Herbert List**
Goldfish Bowl,
Santorini, 1937

Gelatin silver print
28.5 x 23.1 cm
ML/F 1977/969

Gruber Donation

◄ **Man Ray**
Pablo Picasso,
1932–1933

Gelatin silver print
29.9 x 23.9 cm
ML/F 1977/632

Gruber Collection

► **Man Ray**
Kiki, Ingres' Violin,
1924

Gelatin silver print
38.6 x 30 cm
ML/F 1977/648

Gruber Collection

Man Ray
(Emmanuel
Rudnitzky)

1890 Philadelphia,
Pennsylvania
1976 Paris

Man Ray began work in 1911 as a painter and sculptor and had close contact with the European avant-garde. In 1915 he began to turn to photography, working as a freelance photographer, movie-maker, and painter. In 1917 he was co-founder of the New York Dada group. In 1921 he went to Paris, where he worked closely with the Surrealists. In addition to his artistic activities he accepted commercial projects, especially in the areas of portrait and fashion photography. He returned to the USA in 1940, and lived for ten years in Hollywood, where he taught painting and photography. In 1951 he returned to Paris, remaining there until his death. Man Ray is considered to be one of the most important pioneers of contemporary photography. Together with Lee Miller he developed the solarization process, which he used mostly in portraits but also in nude photography. With his "rayographs" he provided an important impetus to camera-less photography. His friendship with avant-garde artists of his time paved the way for the recognition of photography in the artistic context. *RM*

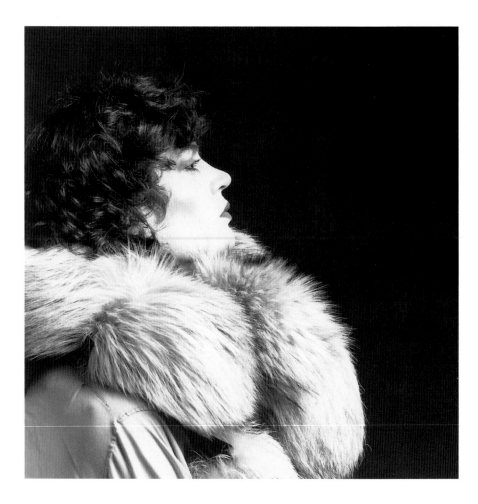

Mapplethorpe, Robert

1946 New York
1989 New York

▲ R. Mapplethorpe
Self-portrait as a
Woman, 1980

Gelatin silver print
35.2 x 35 cm
ML/F 1984/76

Gruber Donation

At first Robert Mapplethorpe wanted to become a musician, but he eventually decided to study painting at the Pratt Institute in Brooklyn. In 1968 he met the singer Patti Smith with whom he moved to the now legendary Chelsea Hotel in Manhattan in 1970. Under the influence of his friend John McEndry, curator for printed art and photography at the Metropolitan Museum of Art, New York, Mapplethorpe began to take an interest in photography, collecting old photographs. Initially he only made montages from photographs that he found, but in 1972 he began to take pictures with a Polaroid camera.

▲ **Will McBride**
Overpopulation,
around 1969

Gelatin silver print
26.7 x 40.5 cm
ML/F 1995/122

Uwe Scheid
Donation

◀ **Will McBride**
Barbara in our Bed,
1959

Gelatin silver print
24 x 37.2 cm
ML/F 1977/489

Gruber Collection

◄ **Duane Michals**
Nude, 1972

Gelatin silver print
12.1 x 17.8 cm
ML/F 1977/513

Gruber Collection

► **Duane Michals**
Paradise Regained,
1968

Gelatin silver prints
6 photographs,
each 16.6 x 24 cm
ML/F 1977/510

Gruber Collection

Michals, Duane

1932 McKeesport,
Pennsylvania
Lives in New York

Duane Michals studied between 1951 and 1953 at the University of Denver and in 1956 attended the Parson School of Design in New York. He took his first photographs in 1958 on a trip through the Soviet Union. Toward the end of the fifties he settled in New York as a freelance photographer, worked for fashion and entertainment magazines such as *Vogue, Esquire, Mademoiselle, Show,* or *New York Times,* and specialized in portrait photography. Even at that time his sense for cryptic, at times dream-like, productions showing his interest in Surrealism manifested itself. In 1963 Michals visited René Magritte, whose paintings he had long found exciting. The series of portraits of this artist is considered a peak of Michals' art because he succeeded in portraying not only Magritte the person but also his world of artistic ideas.

Michals also became famous for his self-staged photo sequences. "I was not satisfied with the individual picture because I could not bend it to provide additional disclosure. In a sequence the sum of pictures indicates what cannot be said by a single picture." Michals used three to fifteen shots to compose picture stories which, however, were not usually complete narrations but mysterious events meant to raise questions and to entice the viewer into further contemplation.

In 1966 Michals began to provide his photographs with hand-written titles which he then expanded into more and more detailed expla-

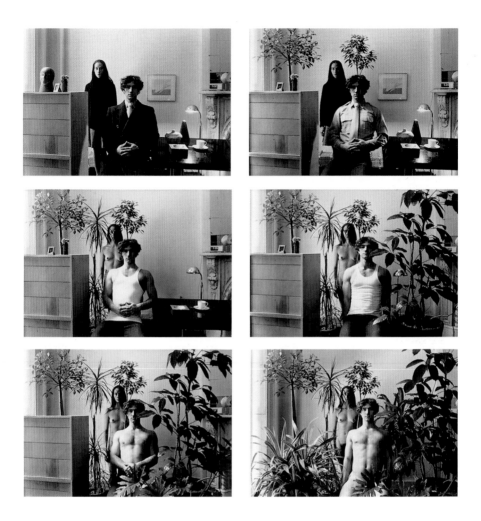

nations. In some cases they even became independent literary texts. Michals wanted to increase the recognition value of his otherwise strictly visual story-telling skill. At the same time he provided the "mechanical" imaging tool of photography with a personal, graphic touch. *MBT*

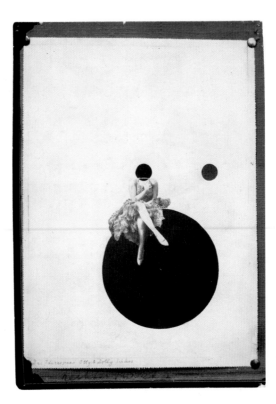

◄ László
Moholy-Nagy
The Olly and Dolly
Sisters Dancing
Duo, 1925

Gelatin silver print
17.8 x 12.5 cm
ML/F 1977/1137

Gruber Donation

► László
Moholy-Nagy
Photogram, 1924

Gelatin silver print
39.7 x 29.8 cm
ML/F 1971/54

Moholy-Nagy, László

1895 Bácsborsod,
Southern Hungary
1946 Chicago

After completing his military service and studying law, László Moholy-Nagy moved in 1920 to Berlin, where he established contact with the Dadaists and Constructivists. Walter Gropius brought him, in 1923, to the Bauhaus, where even before preparing his first photography course he founded "Bauhaus photography". In 1925 his book *Painting, Photography, Motion Pictures* appeared in the *Bauhaus Books* series, in which he coined the word "photo-sculpture" for his photomontages. He grasped these as an "interpenetration of visual content and pun; an uncanny combination of the most realistic imaginative means, which develops into imaginary realms." Moholy-Nagy was involved in assembling the renowned 1929 Stuttgart Werkbund Exhibition "Film and Photo" (FIFO). In 1937 he moved to Chicago, where he assumed the directorship of a design school, which he renamed the New Bauhaus. In 1939, Moholy-Nagy and other artists founded their own School of Design. *MBT*

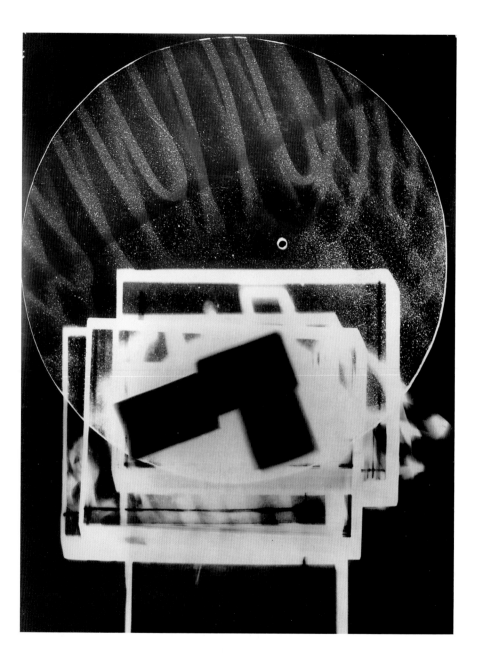

Nauman, Bruce

1941 Fort Wayne,
Indiana
Lives in Pasadena,
California

Bruce Nauman is one of the most significant practitioners of Concept Art in the USA. Although he frequently used photography and film, in particular in the years from 1967 to 1970, he viewed these media merely as forms of documentation for capturing his "Body Art". For Nauman, photography constituted an interesting alternative to traditional media because it offered the advantage of being fast, technologically simple, and (still) unencumbered by the prejudices of the art world.

His *Studies for Holograms* (1970) are based on a 1967 motion picture entitled "Thighing". In 1968 he created his first series of holograms projected on glass and gave it the title *Making Faces*. In 1967 Nauman created a drawing of five unnatural lip positions. On this drawing he wrote the note: "Both lips folded toward the outside; mouth open, upper lip pulled down by the right forefinger; both lips stretched tightly over teeth – mouth open. As above, but with mouth open. Both lips are compressed from the side with the thumb and the forefinger of the right hand." In the series of hologram studies Nauman pulled his face in a similar manner, expanded and stretched in exaggerated forms ending in the absurd. These studies are reminiscent of child's play or abnormal behaviour. "I think I was interested in doing something extreme", Nauman said about this work. "Had I only smiled, it would not have been worth a picture. It would have been sufficient to make a note that I did it. I also could have made a list of things which one can do. But then there was the problem with holograms which require an expression strong enough that one would not think so much of the technical aspect."

In a series of motion pictures he explored the problem of hiding behind a mask. About the motion-picture "Art Make-Up" (1967–1968) Nauman said: "'Make-Up' is not necessarily anonymous, but still somehow distorted; something behind which one can hide. It does not advertise or reveal anything. The tension in the work frequently tells of that. One does not get what one does not get."

◄ ▲ **Bruce Nauman**
Studies for
Holograms, 1970

Screen prints
5 sheets,
each 66.2 x 66.2 cm
ML/F 1970/32 I-V

Neusüss, Floris Michael

1937 Lennep,
Germany
Lives in Kassel

▼ Floris Michael
Neusüss
Night Image I, 1988

Gelatin silver print
50.5 x 37 cm
ML/F 1993/364

Gruber Donation

Floris Michael Neusüss studied photography at the Arts and Crafts School of Wuppertal and at the Bavarian State Educational Institute for Photography in Munich. In 1960 he completed his photographic training with Heinz Hajek-Halke at the College of Creative Arts in Berlin. Already in 1957 he was interested in free, artistic photography. He began with surreal photomontages and photograms, and, in the seventies, developed the nudogram – life-size shadow outlines of nudes, and later of clothed people.

Since the early seventies Neusüss has been conducting a class for experimental photography at the Art Academy of Kassel. There he founded the college gallery as well as the collection and edition of "Fotoforum" Kassel. Both in theory and practice, he dealt with the relationship of photography and art. His exhibitions featuring environmental pollution with pictures like *Photo Recycling Photo* and *Photography, Patience, and Boredom* between the years 1982 and 1985 caused quite a furor.

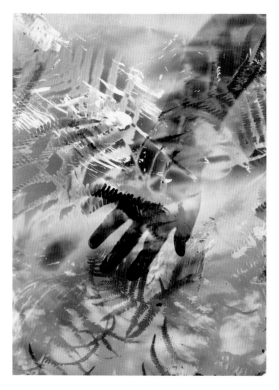

At the beginning of the eighties he created *Artificial Landscapes*, abstract chemical works which looked like reduced excerpts of landscapes or large horizons. Beginning in 1986 he created a new series, his *Night Images*, photographs which are arranged outdoors at night. With his artistic work, teaching and publications, Neusüss has significantly stimulated discussion about the imaging tradition of experimental, in particular camera-less, photography. *RM*

◄ **Floris Michael
Neusüss**
Nudogram, 1966

*Gelatin silver print
on canvas*
231 x 104 cm
ML/F 1979/1155

Gruber Donation

Newman, Arnold

1918 New York
Lives in New York

Since his childhood and youth, Arnold Newman exhibited a talent for drawing and painting. After completing school he began the study of art at the University of Miami, which he had to interrupt because of financial difficulties. At the age of 20 he took a job in a portrait studio in Philadelphia. This was to be the beginning of his successful career as a photographer. Between 1938 and 1942 Newman concentrated on social documentary work, which he shot in the black districts of West Palm Beach, Philadelphia, and Baltimore. In the early forties he specialized more and more in portraits, becoming the star photographer of artists, literary personalities, musicians, and other famous people. Newman developed his own particular style in this field called the "environmental portrait". This refers to Newman's peculiarity of including in the portrait objects characteristic of the portrayed person and of taking the photograph in an environment typical of that person, thereby associating the subject with his work and with the world of ideas. Newman, who did not want to feel himself restricted to the concept of the "environmental portrait", considered the symbolic content of his pictures to be of particular importance. Of his work he said: "I am not so much interested in documentation, but would like to use the means of the steadily expanding language of my medium to express my impressions of the individual." *MBT*

▲ Arnold Newman
Igor Strawinsky, 1946

Gelatin silver print
18.3 x 34.4 cm
ML/F 1977/557

Gruber Collection

▶ Arnold Newman
Piet Mondrian, 1942

Gelatin silver print
24.4 x 14.1 cm
ML/F 1977/555

Gruber Collection

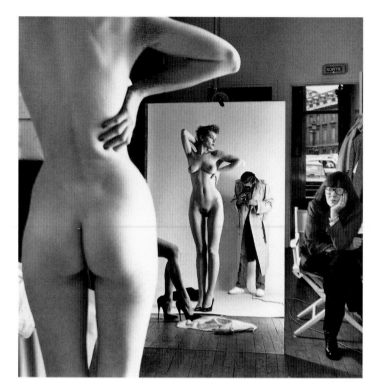

◄ Helmut Newton
Self-portrait with
Wife and Model,
1981

Gelatin silver print
22 x 22 cm
ML/F 1987/3

Gruber Donation

► Helmut Newton
Violetta des Bains,
1979

Gelatin silver print
40.3 x 30.3 cm
ML/F 1993/368

Gruber Donation

Newton, Helmut

1920 Berlin
Lives in Monte Carlo

Helmut Newton, a German by birth now living in Monaco under an Australian passport, did his training under Yva, a Berlin photographer who was famous for her fashion photos, portraits and nudes. Following his training he lived for a number of years in Australia and Singapore, before living and working for 25 years in Paris. He worked at that time for the American, British, French, and Italian issues of *Vogue*, as well as for *Elle, Marie Claire, Jardin des Modes*, American *Playboy*, *Nova* and *Queen*.

Today, few photographers manage to polarise the public quite like Newton. The art world is divided into his fans and his bitter opponents. In point of fact he has created a new style in the world of fashion, beauty and nude photography, which reveals a strong ability to gauge the signs of the times: He combines strident self-presentation with voluntary subjugation. Newton's photography demonstrates the most diverse facets of the different types of women. *RM*

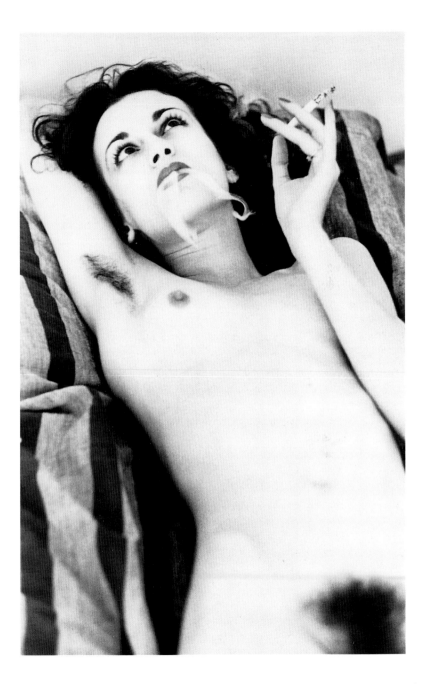

Parks, Gordon

1912 Fort Scott,
Kansas
Lives in New York

▶ **Gordon Parks**
Red Jackson in "The
Harlem Gang Story",
1948

Gelatin silver print
24.2 x 19.1 cm
ML/F 1977/575

Gruber Collection

▼ **Gordon Parks**
Portrait of the
Harlem Story, 1948

Gelatin silver print
32.2 x 26.5 cm
ML/F 1977/566

Gruber Collection

Gordon Parks is the son of a day labourer and the youngest of 15 children. He grew up in his sister's house in Minneapolis until his brother-in-law threw him out at the age of 16. He made a living as a busboy and musician until, seeing pictures of the Farm Security Administration and a weekly newsreel with photographer Norman Alley, he bought a used Voigtländer Brilliant camera and began to take pictures. He started out with fashion photography and, beginning in 1942, also worked for the Farm Security Administration. Between 1949 and 1970 he worked as a photojournalist for *Life* magazine. He portrayed the lives of people in the Southern United States and in Brazilian slums, as well as those of fashionably dressed rich people in New York and Washington. He portrayed artists and produced a touching report about black leader Malcolm X. His pictorial reports from the slums of Harlem, to which he had access being black himself, opened the eyes of white Americans to their own divided country. He became most popular because of his motion pictures, in particular "The Learning Tree" of 1969, and because of his mystery stories, which for the first time had a black as hero. Through his exemplary career, Parks, who could not be hired by Alexey Brodovitch because of the colour of his skin, has contributed greatly to the recognition of blacks in American life. *RM*

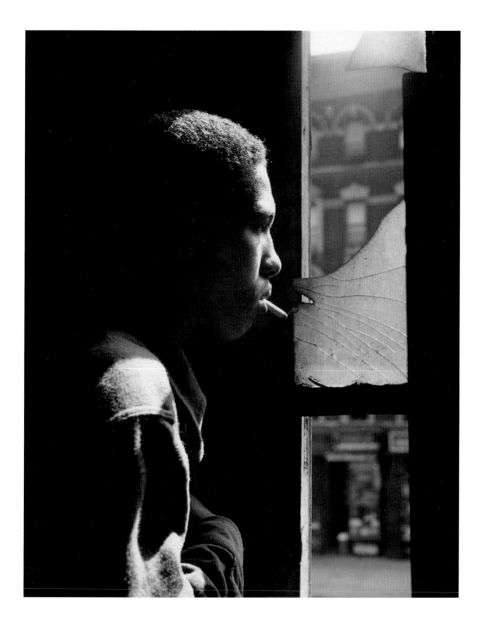

Petrussow, Georgii

1903 Rostow,
Ukraine
1971 Moscow

▼ Georgii Petrussow
Caricature of Rod-
chenko, 1933-1934

Gelatin silver print
29 x 40 cm
ML/F 1992/161

Ludwig Collection

Between 1920 and 1924 Georgii Petrussow worked as a bookkeeper in a bank, devoting his spare time to his hobby of photography. In 1924 he moved to Moscow, where he made his hobby his profession by working as a photojournalist for the trade union papers *Metallist* and *Rabochi-chmik*. Between 1926 and 1928 he worked for *Pravda*. Petrussow specialized in industrial topics. Between 1928 and 1930 he took the post of departmental head of information at the Magnitogorsk mine in the Ural mountains, where he produced a documentary about the building of this plant. During subsequent years Petrussow worked as an associate for the newspaper *USSR under Construction*, creating many photographic essays on the subject of heavy industry. In 1931 he joined the group "October" and worked closely with photographers of the avant-garde, to whom he owed significant encouragement. Photographers like Alexander Rodchenko or Boris Ignatovich affected his style and encouraged him to use bold perspectives and to experiment with photography – as he did, for example, by using a double exposure for *Caricature of Rodchenko* (1933–1934).

► **Georgii Petrussow**
Soldiers with
Helmets, 1935

Gelatin silver print
30 x 25 cm
ML/F 1992/159

Ludwig Collection

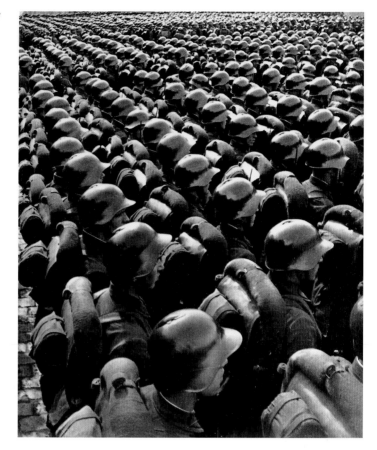

During World War II he worked with Petrussow as a war reporter
for the Soviet Office of Information and the newspaper *Izvestiya*. In
April 1945 he reached Berlin with the first troops and used his camera
to document the Soviet occupation of the city. Between 1957 and 1971
he worked in the USA for the newspaper *Soviet Life*, published by the
"Nowosti" press agency. In 1967 he was honoured with a solo exhibi-
tion in Berlin. *MBT*

**Platt Lynes,
George**

1907 East Orange,
New Jersey
1955 New York

▲ **George Platt
Lynes**
Henri Cartier-
Bresson, around
1930

Gelatin silver print
19.1 x 23 cm
ML/F 1977/473

Gruber Collection

After beginning as a writer and published, George Platt Lynes turned in 1927 to photography, and in 1932 he was able to open his first studio in New York. In 1933 he began to publish his portraits and fashion shots in magazines such as *Town and Country, Harper's Bazaar,* and *Vogue.* Lynes' style took its lead from the European avant-garde and, in particular, Surrealism. In 1942 he moved to Hollywood and became director of the *Vogue* studio.

In 1947, deeply in debt, he returned to New York. During his later years Lynes focused increasingly on erotic male nudes. This brought him neither compensation nor fame, but it increasingly continued to dominate his work. Just before his death Lynes destroyed a large number of his negatives and archived documents because he feared that many of his photographs might be misunderstood. *MBT*

▲ **George Platt Lynes**
Two Nudes, around 1940

Gelatin silver print
24.2 x 19.5 cm
ML/F 1977/482

Gruber Collection

Renger-Patzsch, Albert

1897 Würzburg
1966 Wamel, near
Soest

▲ Albert Renger-Patzsch
Ring-spinning
Machine, Headstock,
1961

Gelatin silver print
22.4 x 16.6 cm
ML/F 1986/240

▲ ▶ Albert Renger-Patzsch
Pipe Air-Release Valve,
1961

Gelatin silver print
22.3 x 15.6 cm
ML/F 1990/898

As a firm opponent of so-called artistic photography, Albert Renger-Patzsch developed a precise photographic style that made him a leading German exponent of the factual rendition of industrial and technical subjects. In publications such as *The World is Beautiful* (1928), *Pioneering Technology* (1928), and *Lübeck* (1928), he couched his industrial photographs in a programmatic context. Renger-Patzsch's factual, realistic photography clearly distanced him from the artistic trends affected by Moholy-Nagy. In 1944 Renger-Patzsch, who was living in Essen, lost his studio during an air raid. After the war he and his family moved to the small village of Wamel near Soest. In the fifties and sixties Renger-Patzsch became well known mostly as a photographer of landscapes and architecture. The fact that he continued to take industrial photographs was not recognized for a long time. Only in 1993 was he honored for this aspect of his later works by the Museum Ludwig in Cologne on the occasion of the exhibition "Albert Renger-Patzsch: Late Industrial Photography". *MBT*

▲ **Albert Renger-Patzsch**
Advertising Picture for the
Jena Works, around 1935

Gelatin silver print, 38 x 28.2 cm
ML/F 1977/655
Gruber Collection

Rodchenko, Alexander

1891 St. Petersburg
1956 Moscow

▲ Alexander
Rodchenko
Dynamo Club, 1930

Gelatin silver print
26.5 x 40 cm
ML/F 1978/1107

Ludwig Collection

▶ Alexander
Rodchenko
On the Parallel Bars,
1938

Gelatin silver print
40 x 28 cm
ML/F 1978/1120

Ludwig Collection

Alexander Rodchenko worked as a sculptor, painter, and graphic artist before turning in the twenties to photomontage and photography. He recognized photography to be *the* artistic medium of his era. Because pictures can be taken with a camera from every position, photography, in Rodchenko's opinion, corresponded to the active eye of man.

By using bold and unusual angles, he wanted to liberate photography from conventions and the normal perspective of seeing, and thus evolved into a decisive pioneer of photographic Constructivism. In 1928 Rodchenko, who had given up painting in favour of photography in 1927, bought himself a Leica, which because of its handy format and quick operation, became his preferred tool for his work. This camera enabled him to realize to excess his ideas of unusual camera positions, severe foreshortenings of perspective, and views of surprising details.

Increasingly Rodchenko's photography was dominated by the artistic element of the line. He liked to integrate elements such as grids, stairs, or overhead wires in his photographic compositions, converting them into abstract constructivistic line structures. *MBT*

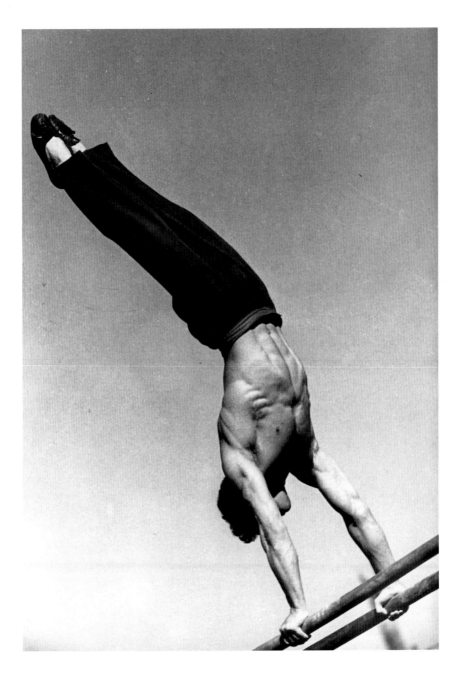

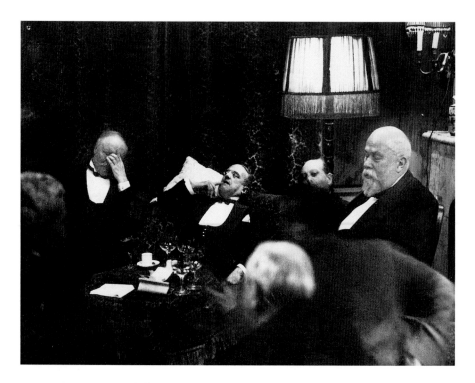

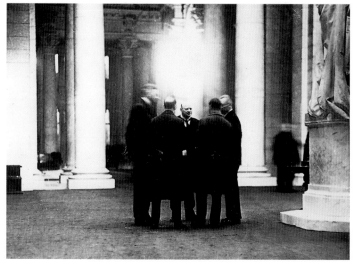

▲ **Erich Salomon**
Round-table Talks,
1930

Gelatin silver print
27.8 x 36 cm
ML/F 1977/685

Gruber Collection

◄ **Erich Salomon**
Dr. Gustav Strese-
mann with Journal-
ists in the Foyer of
the Reichstag, 1928

Gelatin silver print
27.8 x 36 cm
ML/F 1977/676

Gruber Collection

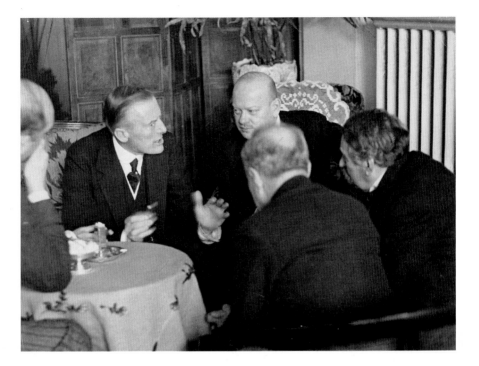

After studying at a university, military service and internment in POW camp, in 1926 Erich Salomon joined the Ullstein publishing house, where he was responsible for public relations work. There he was exposed to photography, which motivated him to acquire his first camera, an Ermanox. In 1928 he attracted attention with a series of pictures he had taken with a hidden camera in a courtroom. These pictures were published in the *Berliner Illustrirte*, which compensated him with two months' wages. He then left Ullstein and began working as a freelance photographer. Salomon's way of photographing political and social events made him the founder of modern political photojournalism. He had the gift for being everywhere without being noticed. He took advantage of his Ermanox camera and its large aperture lens, as well as high-speed glass. Following his emigration to the Netherlands, Salomon was discovered by the National Socialists in Scheveningen, and being a Jew, he was sent to Theresienstadt and later to Auschwitz, where he, his wife and son Dirk were murdered. *RM*

Salomon, Erich

1886 Berlin
1944 Auschwitz

▲ **Erich Salomon**
Summit Conference, Chamberlain, Stresemann and Briand, 1928

Gelatin silver print
26.1 x 35.1 cm
ML/F 1977/690

Gruber Collection

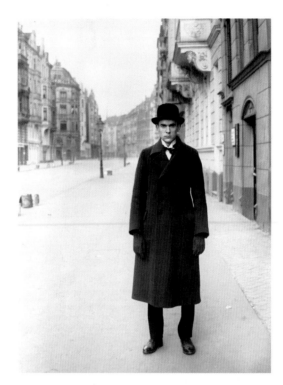

◀ **August Sander**
Anton Räderscheidt,
1927

Gelatin silver print
28.5 x 21 cm
ML/F 1993/434

Gruber Donation

▶ **August Sander**
Young Farmers in
their Sunday Best,
Westerwald, 1913

Gelatin silver print
30.4 x 20.5 cm
ML/F 1977/705

Gruber Collection

Sander, August

1876 Herdorf,
Germany
1964 Cologne

August Sander founded his studio in Cologne-Lindenthal in 1910. There he began his life's work, *People of the 20th Century,* which occupied him into the fifties. In the thirties he got into trouble with the National Socialists on account of his son's political activities, causing him in those years to devote himself almost exclusively to taking pictures of landscapes in the Rhine River area and in old Cologne. Prior to that, by publishing the *Mirror of Germany* and *Face of the Times,* he was able to accomplish at least the initial stage of his idea of an encyclopedic and systematic picture of the German people. Finally, in 1980 the combined work under the original title *People of the 20th Century.* After the destruction of his studio and archive in 1944, Sander moved to Kuchhausen in the Westerwald region. His name was almost forgotten in Cologne until L. Fritz Gruber showed his work at the photokina in 1951
RM

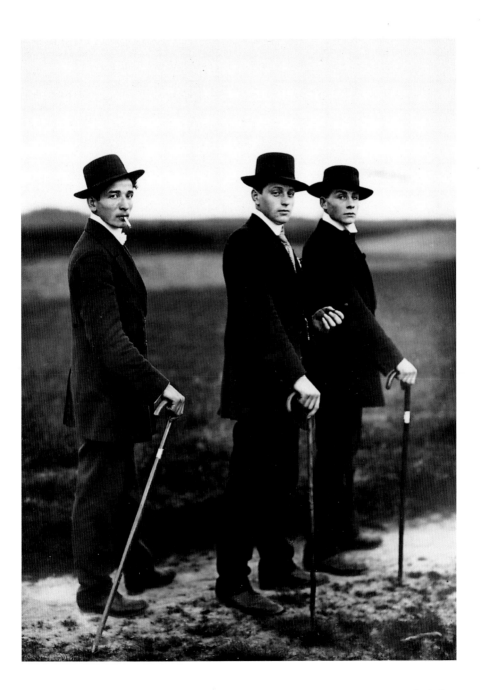

Saudek, Jan

1935 Prague
Lives in Prague

▲ Jan Saudek
Lips with Drop, 1974

Gelatin silver print
15.8 x 22.8 cm
ML/F 1993/443

Gruber Donation

▶ Jan Saudek
Marie No. 1,
around 1986

Gelatin silver print
17.1 x 11.5 cm
ML/F 1994/254

Gruber Donation

To a great extent Jan Saudek's work is marked by two circumstances: by his childhood, when he and his twin brother Karl were interned in a concentration camp, where only by sheer luck they escaped the experiments of Josef Mengele, and by visiting the exhibition "The Family of Man", which he considered an expression of the deep need for familial harmony and which made him aware of photography as a means of expression. Saudek was one of the first Czech photographers whose work became known in the West and this earned him the suspicion of the Czech government until the eighties. His photographs, initially black and white, later in colour, revolve around sexuality and the relationship between men and women, old age and youth, clothing and nudity. Generally, he takes an antagonistic approach to attain powerful pictorial effects. To accomplish this, Saudek sometimes uses strong imaging language, reminiscent of the coarse ribaldry of medieval sexual life, an impression which is enhanced by the always unchanged, drab ambiance of his pictures. Frequently, he stages scenes in which couples appear alternately dressed and naked, young girls reappear pregnant, and children grow older. Without artifice Saudek's photography reaches into life at its fullest. His direct language very quickly met with lively acclaim in the art world. *RM*

◀ Karl Hugo
Schmölz
Hohenzollern
Bridge, 1946

Gelatin silver print
60 x 44 cm
ML/F 1989/192

▶ Karl Hugo
Schmölz
The Cologne Opera,
Architect Riphahn,
1959

Gelatin silver print
48 x 58.6 cm
ML/F 1989/196

Because his father Hugo Schmölz was an architectural photographer, Karl Hugo Schmölz was exposed to photography early on. He took pictures for architects, including Adolf Abel, Bruno Paul, Dominikus Böhm, Gottfried Böhm, Wilhelm Riphahn, and Rudolf Schwarz. Karl Hugo Schmölz returned to his home town after serving in World War II and documented the wartime destruction with a large-format camera. The continuation of his work for the great architects of the Rhineland resulted in an impressive documentation of the reconstruction of the city of Cologne. At the same time Schmölz accepted more and more advertising assignments, and concentrated especially on furniture photography. Today, his archive holds Germany's most comprehensive documentation of 30 years of living in Germany. Following his marriage to photographer Walde Huth, they set up a joint studio under the name "schmölz + huth", thus adding fashion and portrait photography to their range of services. The last assignment he accepted was to take pictures of the new Museum Ludwig in Cologne, but he was unable to complete it. Nevertheless, his "test pictures" had already established the most important focal points of this building, setting the standards for the task. *RM*

Schmölz,
Karl Hugo

1917 Weissenhorn,
Germany
1986 Lahnstein

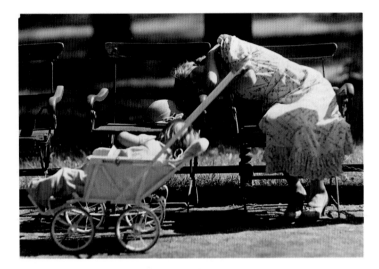

▶ Friedrich
Seidenstücker
Untitled (Sleeping
Man), 1932–1936

Gelatin silver print
17.3 x 12.4 cm
ML/F 1988/104

Gruber Donation

▶ ▶ Friedrich
Seidenstücker
Untitled (Sleeping
Girl), 1932–1936

Gelatin silver print
17.5 x 12.5 cm
ML/F 1988/105

Gruber Donation

Seidenstücker,
Friedrich

1882 Unna
1966 Berlin

▲ Friedrich
Seidenstücker

Untitled (Sleeping
Mother with Baby
Carriage), 1932–1936

Gelatin silver print
13 x 18.2 cm
ML/F 1988/470

Gruber Donation

Friedrich Seidenstücker's first major series was created in the Berlin Zoo, and it showed the specific sense of humor which was evident in much of his work. His powers of observation and his feeling for the comical in everyday situations made him an extraordinary chronicler of Berlin's daily life. Between 1922 and 1930 he made frequent trips to Munich, Paris, Berlin, and Rome and he participated in numerous exhibitions, but he was unable to make a living with his art. Therefore, he decided to become a photographer and entered into a contract with the Ullstein publishing house. He became a chronicler of Berlin life, took pictures in Pomerania and Prussia and produced photo-reports for *Berliner Illustrirte*. He became famous, in particular, for his pictures of daily life in Berlin and for his *Puddle Jumpers*, young women and girls in summer dresses who with legs spread, at times umbrella in hand, jumped over puddles onto the sidewalk. *RM*

▶ Friedrich
Seidenstücker
Untitled (Sleeping
Couple), 1932–1936

Gelatin silver print
17.5 x 13 cm
ML/F 1988/102

Gruber Donation

▶ ▶ Friedrich
Seidenstücker
Untitled (Sleeping
Dog), 1932-1936

Gelatin silver print
17.5 x 12 cm
ML/F 1988/103

Gruber Donation

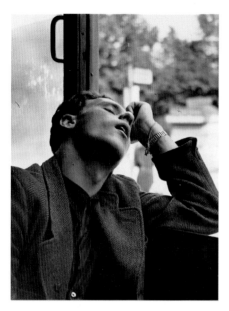

Sherman, Cindy

1954 Glen Ridge,
New Jersey
lives in New York

▼ **Cindy Sherman**
Untitled # 222, 1990

c-print
152,4 x 111.8 cm
ML/F 1999/58

Permanent loan of
the Gesellschaft für
Moderne Kunst am
Museum Ludwig

Cindy Sherman studied painting and photography at the State University College in Buffalo, New York. In 1977 she embarked on her first series of photographs, the *Untitled Film Stills*, which draw stylistically on the aesthetics of popular American films of the fifties. Cindy Sherman always places herself at the centre of these film scenes, which reproduce the cinema clichés typical of soap operas and love stories. The stills have such a familiar feeling about them it is as if the viewer had seen them before. During the following years Sherman turned to colour photography and here broke the usual moulds of traditional photography. She produced her *History Portraits* (1988–90), in which she ostensibly features famous women of history, the *Disasters*, which showcase confectionery arranged in a variety of repulsive ways, and her *Sex Pictures* (1992), for which she created arrangements of objects from sex shops, together with erotic underwear and surgical implements. Additionally, Sherman created a series on fashion photography in which she combined in truly grotesque manner fashion with weird and ludicrous models. The result turned the idea behind fashion photography – displaying clothes in attractive ways – totally on its head. Cindy Sherman was never shy of presenting her own self in repulsive contexts, she has constantly slipped into new roles and thus positioned her art in a large number of different contexts, from feminism to cultural studies, although the perspectives of psychoanalytic interpretation run as an unmistakable thread through all of her work cycles. *RM*

▶ **Cindy Sherman**
Untitled # 152, 1985

c-print
183.6 x 126 cm
ML/F 1999/59

Shinoyama, Kishin

1930 Tokyo
Lives in Tokyo

▲ **Kishin Shinoyama**
Two Rear Views of
Nudes, 1968

Gelatin silver print
19.8 x 30.6 cm
ML/F 1977/764

Gruber Collection

Kishin Shinoyama, the son of a Buddhist monk, was supposed to follow in his father's footsteps and become a monk at his temple. Instead, he let his brother take his place and opted in favour of photography. Between 1961 and 1963 he studied photography at Nihon University in Tokyo. Between 1961 and 1968 he worked for the Light-House advertising agency in Tokyo. Since 1968 Shinoyama has been working as a freelance photographer in the areas of fashion, sports, advertising, and the press. In 1970 he was honoured by the Japanese Association of Photographers as Photographer of the Year. He became known as a photographer of nudes, and his pictures were exhibited at photokina. His nudes attracted attention because he did not adhere to conventions, but rendered highly formalized views of the body. Shinoyama saw nude photography as a modelling problem encountered by a sculptor, leading him at times to create abstract forms. In 1974 he caused an international sensation with his series on the Tattooing House in Yokohama. Shinoyama followed this up with a quiet, almost meditative study of traditional Japanese houses and gardens, offering the European world an intimate glance at the Japanese way of life. Nevertheless, he continued to pursue nude photography with great intensity. In 1985 he published *Shinorama*, a series for

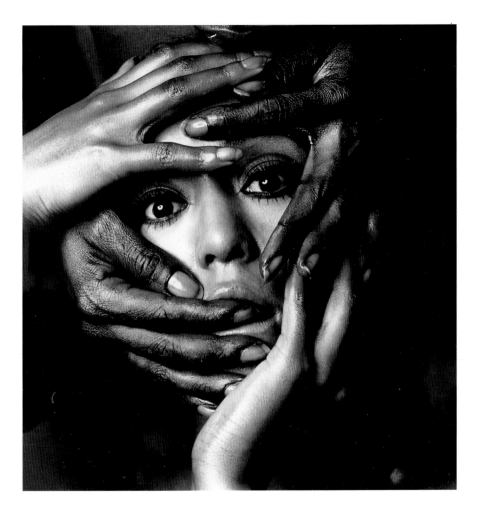

which he photographed nude dancers with nine cameras triggered at
the same time, so that the final picture was composed of as many parts.
In 1990 he also employed the large format with his photographic series
Tokyo Nude, for which he arranged panorama-like overviews of nudes to
create a surreal world which is illuminated artificially and populated by
doll-like beings. Today, Shinoyama is considered to be one of the leading
Japanese photographers, representing the generation that brought
recognition to Japanese photography all over the world. *RM*

▲ **Kishin Shinoyama**
Brown Lily, 1968

Gelatin silver print
18.8 x 18.7 cm
ML/F 1977/766

Gruber Collection

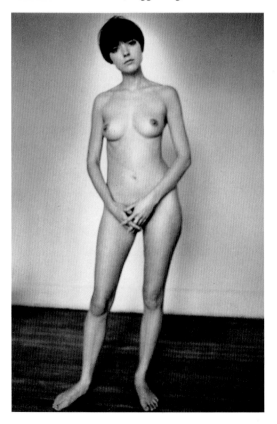

Sieff, Jeanloup

1933 Paris
2000 Paris

▼ Jeanloup Sieff
Homage to Seurat,
1964

Gelatin silver print
30 x 20 cm
ML/F 1984/114

Gruber Donation

In 1953 Jeanloup Sieff studied literature, journalism and photography at the Vaugirard School of Photography in Paris. A year later he studied photography in Vevey, Switzerland. He began his career as a freelance journalist in Paris, working for *Elle* as a photojournalist and fashion photographer between 1955 and 1958. Following a brief membership in "Magnum" in 1959, during which he reported from Greece, Turkey, and Poland, he worked as a freelance photographer until 1961, winning the "Prix Nièpce" in the same year. Since then, he has photographed fashion for all the important magazines, including *Harper's Bazaar, Glamour, Esquire, Look, Vogue,* and *twen,* in both the USA and Europe.

Sieff was also a celebrated photographer of nudes. One of his stylistic tools was the wide angle, which gives his nudes a feeling of dreaminess, suggesting a kind of distance of the naked models, even though they are often looking directly at the camera. Sieff is less known for his excellent landscape photographs. *Black House* of 1964 is an early example of this genre – a picture that indicates the dramatizing effect of a 28 mm lens and the virtuosity with which Sieff captures in his black-and-white photographs on the one hand the textures of wood and red grass and on the other silhouettes, shadows and sky formations. *AS*

▶ Jeanloup Sieff
Black House, 1964

Gelatin silver print
30 x 20 cm
ML/F 1984/113

Gruber Donation

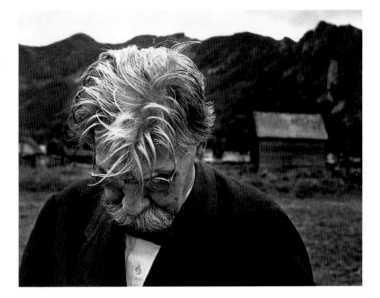

▶ **W. Eugene Smith**
Albert Schweitzer,
1949

Gelatin silver print
26.7 x 34.2 cm
ML/F 1977/773

Gruber Collection

◀ **W. Eugene Smith**
Charlie Chaplin Dur-
ing the Filming of
"Limelight", 1952

Gelatin silver print
34.2 x 25.9 cm
ML/F 1977/778

Gruber Collection

W. Eugene Smith rendered outstanding services to photojournalism
with his extraordinary political and social commitment. In 1936 he
moved to New York, where he studied under Helene Sanders at the
New York Institute of Photography. In 1937 and 1938 Smith worked as a
photojournalist for *Newsweek* before moving to the "Black Star" agency
as a freelance photographer. Between 1939 and 1942 he had a contract
with *Life* magazine. After the war and after his recovery Smith returned
to *Life* magazine. During subsequent years he had an impact on the
photography of this magazine, because he wanted to do away with the
conventional approach of using pictures as mere illustrations to accom-
pany the text, wanting instead to give greater emphasis to the pictures
themselves. As a result of this, Smith was instrumental in the develop-
ment of the independent form of the photo-essay. One of his most
famous pieces of journalism in this regard was the photographic series
on a Spanish village, published in *Life* in 1951. In 1955 Smith left *Life*
magazine to work with the "Magnum" agency, a relationship that he
kept up until 1959. During subsequent years the photographer discov-
ered the book as a suitable medium for publishing his photographs.
By using this medium, he could exercise complete control over the
presentation of his photographs. *MBT*

Smith,
W. Eugene

1918 Wichita, Kansas
1978 Tucson,
Arizona

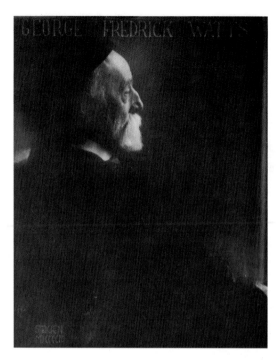

◀ Edward Steichen
George Fredrick
Watts, from: *Camera Work* 14, 1906

Photogravure
21.2 x 16.5 cm
ML/F 1995/47

Gruber Donation

▶ Edward Steichen
Small Round Mirror,
from: *Camera Work* 14, 1906

Photogravure
14.2 x 21.4 cm
ML/F 1995/51

Gruber Donation

**Steichen,
Edward**

1879 Luxembourg
1973 West Redding,
Connecticut

Edward Steichen was born in Luxembourg and grew up in the USA. After studying art and an apprenticeship as lithographer, he began in 1895 working in the style of artistic photography. In 1902 Steichen became one of the founding members of "Photo Secession" in New York. By spending several years in Paris, Steichen became familiar with local avant-garde art and arranged exhibitions for artists in the USA. During World War I, Steichen acted as a photographer for the Air Force and the Marines, an assignment that was to change his photographic style fundamentally. The precision required by aerial photographs taught him to appreciate the beauty of non-manipulated photography. In 1923 Steichen became the chief photographer at Condé-Nast, where he was responsible especially for the fashion magazines *Vanity Fair* and *Vogue* until 1938. He advanced to become one of the best-paid fashion and portrait photographers of his time. After World War II, he embarked on a second career as director of the photographic department of the Museum of Modern Art in New York. *MBT*

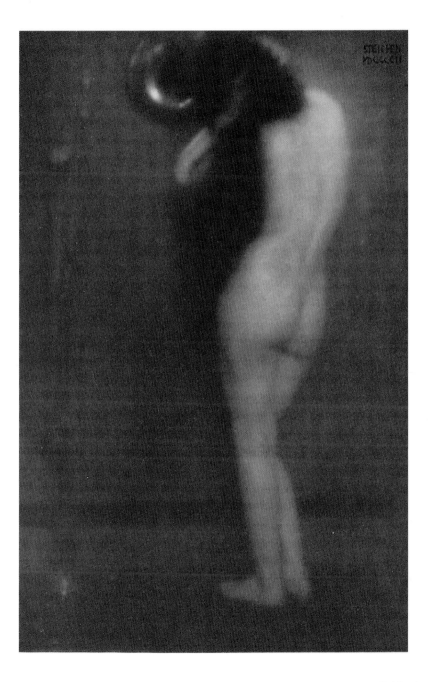

Otto Steinert, who made history as an outstanding personality of German post-war photography, started out wanting to become a physician. In 1934 he began to study medicine, graduating in 1939. After World War II he worked as a doctor in residence in Kiel from 1945 to 1947. Simultaneously, however, he taught himself photography, eventually giving up his profession as a physician to pursue his passion for photography. In 1948 he became the director of the photographic class at the State College of Arts and Trades in Saarbrücken. There, he, Peter Keetman, Ludwig Windstoßer, and others, founded the group "foto-form" in 1949, which was dedicated to rekindling people's awareness of the photographic design possibilities and modes of expression of the pre-war avant-garde, which had been suppressed by the dictatorial cultural policy of the National Socialists. In 1951 Steinert organized the first of three exhibitions whose title "subjective photography" was to become synonymous with a whole new direction in style. In the second catalogue of this small series of exhibitions Steinert explained: "We feel

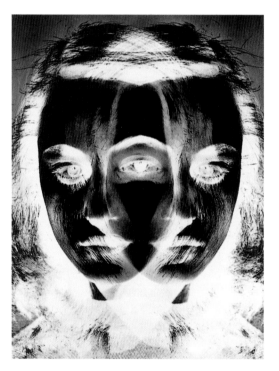

► **Otto Steinert**
Dancer's Mask, 1952

Gelatin silver print
34.5 x 26.5 cm
ML/F 1977/817

Gruber Collection

all the more obligated [...] to encourage all efforts to work actively and creatively on the synthesis of the creative, contemporary photographic image and to generate a genuine relationship with photographic image quality." High-contrast prints, radical cropping, abstract structures, surreal-looking situations, negative prints, and solarizations became the favourite forms of expression espoused by Steinert and his students. Their idols were photographers such as Man Ray and especially László Moholy-Nagy.

In 1959 Steinert accepted an invitation to teach at the Folkwang School of Design in Essen, where he directed the photography work group until he passed away. During these years Steinert not only acted as a photographer and teacher, but also assembled an excellent photographic collection. *MBT*

▲ **Otto Steinert**
Pedestrian's Foot,
1950

Gelatin silver print
28.7 x 40 cm
ML/F 1977/818

Gruber Collection

Stern, Bert

1929 New York
Lives in New York

Bert Stern is a self-taught photographer. In 1951 he was a cameraman for the US Army in Japan. Since 1953 he has been working as a fashion and advertising photographer. He was one of the first to design newspaper advertisements in colour that were difficult to distinguish from editorial picture pages. His style can be circumscribed with words such as glamour, romanticism, and delicacy: "If you want to be seduced by the camera, by a man who can fall in love with any object, go see Bert Stern", is how a publisher characterized him. His outstanding abilities in portrait photography were especially noticeable in *Louis Armstrong*, a picture taken around 1959 on the occasion of an advertising campaign for an early Polaroid film. The sharpness of detail and gradation of the black-and-white tones was perfect to a point that the client considered it "too good", but still had it printed. But without doubt the most famous of Stern's photographs are those he took of Marilyn Monroe. They were shot during her last photographic session for *Vogue* magazine at a Los Angeles hotel in June of 1962, six weeks before she died. In the course of three days Stern shot almost 2700 pictures, including portraits, fashion photographs and nudes, which were published in the 1992 picture book *The Complete Last Sittings* and which attest to the unique intimacy and understanding between model and photographer during that ses-

▼ Bert Stern
Eartha Kitt, around 1956

Gelatin silver print
28.1 x 27.4 cm
ML/F 1977/824

Gruber Collection

sion. At that time *Vogue* published a total of eight of the black-and-white shots. Bert Stern became increasingly successful during the sixties, but his photographs of Marilyn Monroe remained very special: "In the course of the years I noticed that the pictures we had taken together now belonged to everyone. What we created had grown beyond me. Somehow they slipped away from me and into the dreams of everyone." *AS*

▲ **Bert Stern**
Louis Armstrong, around
1959

Gelatin silver print
41.9 x 34.5 cm
ML/F 1977/821

Gruber Collection

Stieglitz, Alfred

1864 Hoboken,
New Jersey
1946 New York

Alfred Stieglitz was the son of a well-to-do German-Jewish family. He studied in Berlin, where he trained under Hermann Wilhelm Vogel, the inventor of orthochromatic film. Initially, he was particularly keen on the functional, scientific aspect of his studies of photography. His first works, oriented to conventional photography, were created in 1883 in Berlin. In 1890, at the age of 26, he returned to New York. After quickly reaching the technical limits of photography, Stieglitz began to look for new methods of exposure and processing. Together with Joseph T. Keiley, he invented "pure photography", using the gelatine process.

In 1902 Stieglitz, Edward Steichen, and Alvin Langdon Coburn founded "Photo Secession" and the journal *Camera Work*. The photographers of "Photo Secession", including Gertrude Käsebier, Clarence H. White, and Frank Eugene, did not so much see mimetic qualities in photography, but the spiritual expression of the artist himself. In the aesthetics of his pictures Stieglitz emphasized his own perception, totally independent of any viewing tradition. His photography remained quite untouched by the group's goal of artistic aesthetics. His main subjects in those years were the city of New York and the formal, architectural aspects of its buildings. In 1905 Stieglitz opened Gallery 291 at 291 Fifth Avenue in New York City, where he introduced the European avant-garde to America.

In 1917, the last year *Camera Work* was published, he met Georgia O'Keeffe, a photographer and later his life companion, whose pictures he exhibited in 1926 in his second gallery, the Intimate Gallery. Stieglitz took numerous photographs of Georgia O'Keeffe, which set new standards in portraiture. They exhibited unadulterated directness and the search for objective truth through "pure photography". In 1929 Stieglitz' second gallery was closed. Soon he opened another one, "An American Place", which he operated until his death. Although he managed his gallery more on idealistic than commercial lines, Stieglitz mainly saw himself as a photographer who wanted to convey what he saw – his "idea photography". In 1922 he photographed a series of clouds at Lake George, which were of an abstract nature. *LH*

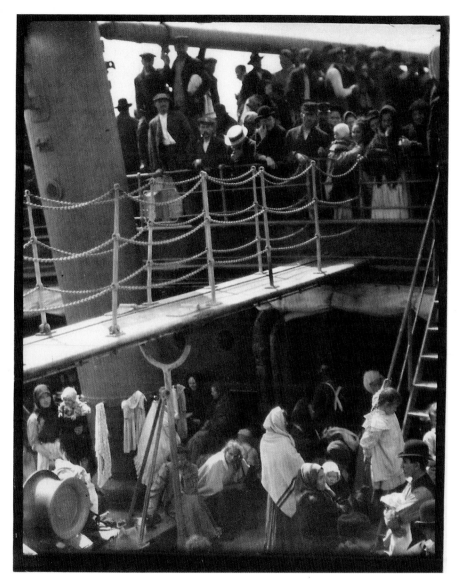

▲ **Alfred Stieglitz**
The Steerage, 1907

Heliogravure
19.7 x 15.8 cm
ML/F 1982/1

◄ **Paul Strand**
Still Life, Pear and
Bowls, Twin Lakes,
around 1915

*Handgravure,
provided by the
Aperture Foundation*
25.6 x 28.8 cm
ML/F 1994/292

Gruber Donation

► **Paul Strand**
Abstraction,
Shadows of a
Veranda, Connecti-
cut, 1916

*Handgravure,
provided by the
Aperture Foundation*
33.1 x 24.3 cm
ML/F 1994/291

Gruber Donation

Strand, Paul

1890 New York
1976 Orgeval, France

In 1909 Paul Strand completed his studies under Lewis Hine at the Ethical Cultural School in New York. Hine introduced him to Alfred Stieglitz, the founder of "Photo Secession" and the publisher of *Camera Work*. Strand began producing abstract photographs in 1915. In 1917, the last double-edition of *Camera Work* was dedicated exclusively to Strand's photographs. He imparted this medium with a new direction in style, called "straight photography" ever since. The traditional orientation to painting was replaced by a self-assured exploration of the genuinely photographic, where the charm is frequently found in the mundane, in a structure, or in the shadow of the world of things, in excerpts and rhythms. *Abstraction, Shadows of a Veranda, Connecticut* (1916) is representative of this style. Strand's works cover almost all subjects, including portraits and documentary pictures, landscapes and plant photography, architectural themes and photographs of machines and industrial sites. *AS*

Ueda, Shoji

1913 Sakaiminato,
Japan
Lives in
Sakaiminato-shi

Shoji Ueda completed his formal training under Toyo Kikuchi at the Oriental School of Photography. Ueda opened his first studio in his home town in 1933. Ueda points out that, because in Japan photography is not held in the same high esteem as painting, he fostered the new age with a cosmopolitan way of thinking. He is frequently called a "poet of images". Ueda's main subjects are people set in landscapes, such as the sand dunes of the Samin region. The staged character of his pictures is conspicuous in his publication *Dunes* of 1978, and also in *Children the Year Round*. A person, be it in the form of a rear view of a nude, a man with a bowler hat, or a child, is the extraneous object in the dunes with an infinite expanse of sky. Frequently the horizon provides the only boundary, and spatial concepts are often suspended. Ueda plays with artificial perspective tricks in nature. Clothes hangers, carpets, and bowler hat, are often used to confuse perspective viewing.

Since 1975, Ueda has been a professor at the Kyushyn Sangyo University in Sakaiminato-shi. *LH*

▲ **Shoji Ueda**
Silhouette Pro-
cession, 1978

Color print, satiny
23.8 x 36.2 cm
ML/F 1984/121

Gruber Donation

► **Umbo**
Sinister Street, 1928

Gelatin silver print
29.8 x 22.8 cm
ML/F 1981/574

From 1921 to 1923 Umbo studied at the Bauhaus in Weimar. In 1926
he produced photomontages for Walter Ruttmann's film "Berlin". He
made the acquaintance of Paul Citroen, the painter, who introduced
him to photography. The actress Ruth Landshoff became his preferred
model for his innovative portraits, a combination of the broad view of
the motion picture and the classical portrait. He adopted the pseudo-
nym Umbo, and his pictures of large cities, portraits and photograms
earned him international acclaim as one of the leading German avant-
garde artists of the twenties. His style influenced the photojournalism
of "Dephot" (German Picture Agency). During the time of the National
Socialist regime he joined the resistance movement, and his agency
was closed. During World War II Umbo lost his entire archive, and his
significance went unrecognized until he was finally rediscovered in
1978 as a pioneer of modern art. *RM*

Umbo
(Otto Maximilian
Umbehr)

1902 Düsseldorf
1980 Hanover

Weegee
(Arthur H. Fellig)

1899 Zloczwe
1968 New York

▼ **Weegee**
Nikita Khrushchev,
1959

Gelatin silver print
22.7 x 19 cm
ML/F 1977/845

Gruber Collection

Arthur H. Fellig, called Weegee, emigrated in 1910 with his family from Austria to New York, where he grew up in poor circumstances on the Lower East Side. In 1914 he quit school prematurely in order to help support his family.

In 1935 Weegee started working as a freelance photojournalist, and chased sensational events such as road accidents, violent crimes, and catastrophic fires. He sent these pictures to the tabloid press. Thanks to his friendly contacts with policemen of the Manhattan Police Head-quarters, Weegee was informed about every crime and accident as soon as the policemen themselves. In 1938 he even received permission to install a police radio in his car, so that he was often the first at the scene, and no less important for the tabloid press, could be the first to submit photographs to his editor. In his photographs he captured traces of the Great Depression with anguishing directness. To this day, his work constitutes an impressive documentation of life in modern large cities marked by brutality and mercilessness. As a balance to this, Weegee began taking pictures of High Society in 1938. These photographs reflect a sarcastic opinion of the rich, decadent stratum of society. Weegee liked to use strong flashlight, producing dramatic effects of light and shadow.

In 1947 Weegee moved to Hollywood, where worked as a technician and actor in small parts while collecting material for his new book *Naked Hollywood*. In 1952 he returned to New York and produced mainly caricatures of personalities in politics and society. Weegee developed a kaleidoscope for his camera, calling it a "Weegeescope". *MBT*

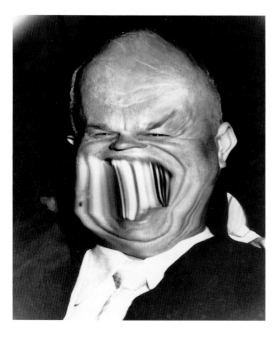

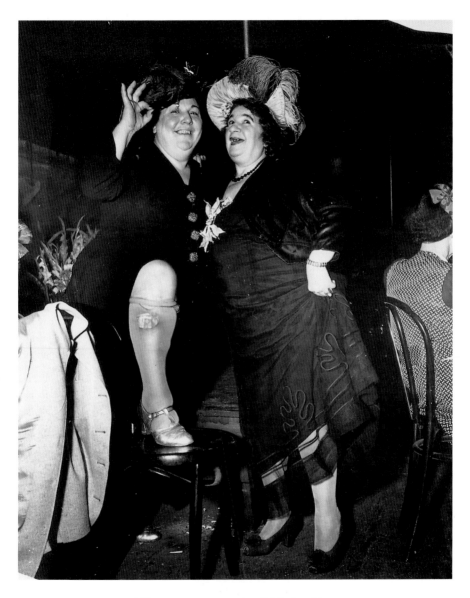

▲ **Weegee**
Billie Dauscha (left) and Mabel
Sidney (right), Bowery Enter-
tainers, December 4, 1944

Gelatin silver print
24.1 x 19.8 cm
ML/F 1977/849
Gruber Collection

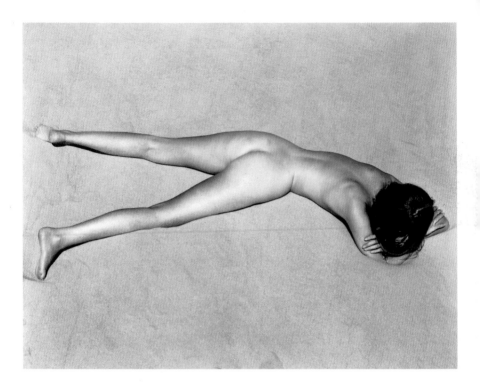

**Weston,
Edward**

1886 Highland Park,
Illinois
1958 Wildcat Hill

▲ Edward Weston
Nude, 1936

Gelatin silver print
19.1 x 24.1 cm
ML/F 1977/855

Gruber Collection

Edward Weston, a pioneer of "straight photography", developed from his Pictorialist beginnings to a clear, precise style – not least due to the encouragement given by his friends Alfred Stieglitz, Charles Sheeler, and Paul Strand. His photos of the Armco Steelworks in Middletown, Ohio, of 1922 mark the turning point in Weston's career. In 1923 he opened a portrait studio in New Mexico, where he established contact with Diego Rivera, Frida Kahlo, and other Mexican artists and intellectuals. In his nudes, still lifes and "close-ups" Weston shows his especial sensitivity to surfaces, which he lends an almost tactile dimension. He wanted to place the "thing-in-itself", the essence, before the viewer's eye. In 1932 along with Ansel Adams, Imogen Cunningham, and others, Weston founded the group "f/64", which was to become an important forum for "straight photography". He was awarded a grant by the John Simon Guggenheim Memorial Foundation in 1937, which allowed him to travel for two years around California and the neighbouring states. *MBT*

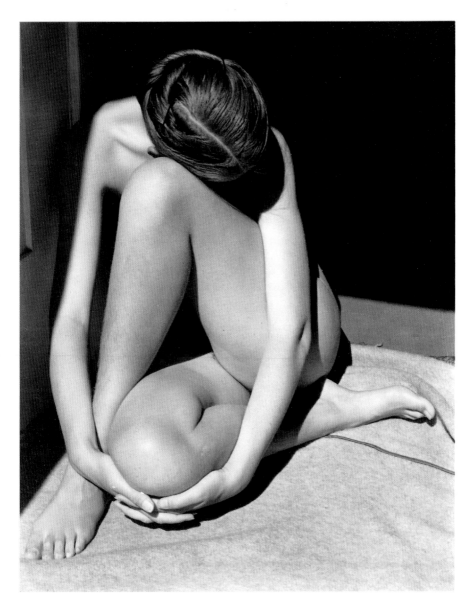

▲ Edward Weston
Nude, 1936

Gelatin silver print, 24.5 x 19.3 cm
ML/F 1977/850

Gruber Collection

► Joel Peter Witkin
Courbet in Rejlan-
der's Pool, 1985

Gelatin silver print
38.2 x 37.9 cm
ML/F 1995/129

Uwe Scheid
Donation

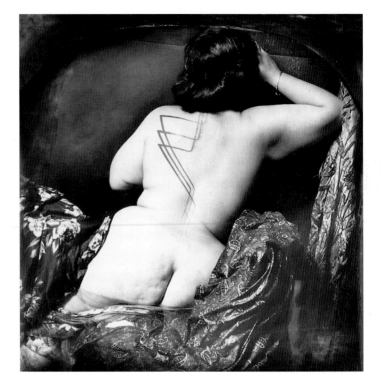

Witkin,
Joel Peter

1939 New York
Lives in
Albuquerque,
New Mexico

At first, Joel Peter Witkin worked as a technician in a studio producing dye transfer prints, and then as an assistant in two photographic studios. After that, he worked as a military photographer. In 1967 he began to freelance, becoming the official photographer for City Walls Inc. in New York. Later on he studied at the Cooper Union School of Fine Arts in New York, where he obtained his Bachelor of Arts degree in 1974. After receiving a scholarship for poetry at Columbia University in New York, he completed his studies at the University of New Mexico at Albuquerque with a Master of Fine Arts degree, and he currently teaches photography at that school. In the eighties, Witkin shocked the public with photographs of misshapen people, of parts of corpses, and by staging events of church history, frequently citing known master-pieces in a morbid way. Many of his works are reminiscent of Hierony-mus Bosch. Even though he is a maverick, he has gained acceptance in the established art scene. *RM*

Unless otherwise specified, copyright on the works reproduced lies with the respective photographers. Despite intensive research it has not always been possible to establish copyright ownership. Where this is the case we would appreciate notification.

Adams: © The Ansel Adams Publishing Rights Trust, Mill Valley | **Arbus**: Copyright © The Estate of Diane Arbus, New York | **Avedon**: © 1955 Richard Avedon | **Bayer**: © VG Bild-Kunst, Bonn 2001 | **Beaton**: © Cecil Beaton photographs courtesy of Sotheby's London | **Bing**: © Ilse Bing Estate, courtesy Edwynn Houk Gallery, New York | **Bischof**: © Bischof Estate, Zürich | **Bourke-White**: © LIFE Time-Pix/interTOPICS | **Brassaï** © The Estate of Brassaï, Paris | **Burri**: © Magnum/Focus | **Callahan:** © The Estate of Harry Callahan, courtesy Pace/MacGill Gallery, New York | **Capa**: © Magnum/Focus | **Cartier-Bresson**: © Magnum/Focus | **diCorcia**: © Philip-Lorca diCorcia, courtesy Pace/MacGill Gallery, New York | **Drtikol**: © Ervina Boková-Drtikolová, Poděbrady | **Edgerton**: © Harold & Esther Edgerton Foundation, 2001, courtesy of Palm Press, Inc. | **Eisenstaedt**: © LIFE TimePix/interTOPICS | **Elsken**: © Ed van der Elsken/The Netherlands Photo Archives | **Evans**: © Walker Evans Archive, The Metropolitan Museum of Art, New York | **Feininger**: © LIFE TimePix/interTOPICS | **Finkelstein**: © Fritz Böhme, Galerie eye gen art, Köln | **Haas**: © Tony Stone/Getty Images | **Halsman**: © Magnum/Focus | **Hamaya**: © Magnum/Focus | **Helnwein**: © Gottfried Helnwein | **Henle**: © Maria Henle, Christiansted, St. Croix | **Henri**: © Galleria Martini & Ronchetti, Genova | **Hockney**: © David Hockney | **Horst**: © R. J. Horst for Horst P. Horst, New York | **Hoyningen-Huene**: © R. J. Horst for Horst P. Horst, New York | **Kertész**: © Ministère de la Culture, France | **Kimura**: © Naoko Kimura, Tokyo | **Klein**: © Klein/Focus | **Lange**: © The Dorothea Lange Collection, Oakland Museum of California, City of Oakland. Gift of Paul S. Taylor | **Lartigue**: © Association des Amis de Jacques-Henri Lartigue, Paris | **Lissitzky**: © VG Bild-Kunst, Bonn 2001 | **List**: © Max Scheler, Hamburg | **Man Ray**: © Man Ray Trust, Paris/VG Bild-Kunst, Bonn 2001 | **Mapplethorpe**: All Mapplethorpe works copyright © The Estate of Robert Mapplethorpe. Used with permission | **Moholy-Nagy**: © VG Bild-Kunst, Bonn 2001 | **Nauman**: © VG Bild-Kunst, Bonn 2001 | **Newman**: © All Photographs copyrighted by Arnold Newman | **Newton**: © Helmut Newton | **Platt Lynes**: © Courtesy Estate of George Platt Lynes, Linda Hyman Fine Arts, New York | **Renger-Patzsch**: © Albert Renger-Patzsch-Archiv, Ann und Jürgen Wilde/VG Bild-Kunst, Bonn 2001 | **Salomon**: © Bildarchiv Preußischer Kulturbesitz, Berlin | **Sander**: © Photographische Sammlung/SK Stiftung Kultur – August Sander Archiv, Köln/VG Bild-Kunst, Bonn 2001 | **Schad**: © Archiv Christian Schad, Bessenbach-Keilberg | **Seidenstücker**: © Ulrich Wolff, Bielefeld | **Sherman**: © Cindy Sherman, courtesy of Metro Pictures, New York | **Smith**: © Magnum/Focus | **Steichen**: © Reprinted with permission of Joanna T. Steichen | **Stieglitz**: © Georgia O'Keeffe Foundation | **Strand**: © Paul Strand Archive, Aperture Foundation, Millerton | **Umbo**: © Kicken Berlin | **Weegee**: © Weegee 1998/International Center of Photography/Hulton Getty | **Weston**: © 1981 Center for Creative Photography, Arizona Board of Regents

"Buy them all and add some pleasure to your life."

www.taschen.com